HAUNTED DOOR COUNTY

HAUNTED DOOR COUNTY

GAYLE SOUCEK

Published by The History Press
Charleston, SC 29403
www.historypress.net

Front cover courtesy of Peter Rimsa.

First published 2012
Second printing 2014

Manufactured in the United States

ISBN 978.1.60949.474.2

Library of Congress Cataloging-in-Publication Data

Soucek, Gayle.
Haunted Door County / Gayle Soucek
p. cm.
ISBN 978-1-60949-474-2
1. Ghosts--Wisconsin--Door County--Anecdotes. 2. Haunted places--Wisconsin--Door
County--Anecdotes. 3. Parapsychology--Wisconsin--Door County--Anecdotes. 4. Door
County (Wis.)--Social life and customs--Anecdotes. 5. Door County (Wis.)--Biography--
Anecdotes. I. Title.
BF1472.U6S67 2012
133.109775'63--dc23
2012029030

CONTENTS

CONTENTS

FOREWORD

A whimsical gift from retreating glaciers of the last Ice Age, the Door Peninsula juts defiantly into the big blue waters of Lake Michigan. Long before Europeans discovered its riches, the Peninsula's dense forests and living waters were irresistible to the native peoples. Its numerous nearby islands offered comfortable sanctuaries with easy access to great expanses of open water, facilitating freedom of movement along its shores. In the 1600s, French explorers found their way to the peninsula and its islands by boat. Their arrival opened the way for a steady stream of sailors and pioneers who would navigate the waters and trails and who would harvest lumber, stone, fish and the other resources available along the peninsula's diverse and sometime dangerous coastline.

These were rugged, resourceful men and women—bold sea captains, brave seamen, hearty lumberjacks, rugged fishermen and powerful quarrymen. The peninsula's history is punctuated by a long list of incredible characters and dramatic events. Its rocky shoals, treacherous channels, lonely coastline and the countless shipwrecks it has wrought are legendary. This tapestry of intriguing humans, lonely places and all manner of disasters is fertile ground for wonderful tales and amazing stories.

The county's name itself is shrouded in mystery. Porte des Morts ("Death's Door") is the chief navigational passage between the Bay of Green Bay and Lake Michigan. It lies between the end of the Peninsula and the rocky shores of Pilot, Plum, Detroit and Washington islands. The legends surrounding Death's Door portray many a grim scene worthy of the passage's moniker.

They tell of a huge Indian war party pummeled to death against its rocky shores as the natives attempted to cross from the islands to the mainland to make war on adversaries. They recount the last voyages of innumerable wooden sailing ships pulverized by swirling currents and howling gales.

But like a fierce squall that blurs the line between sea and sky, the potent legacy of Death's Door obscures the line between fact and fancy. The precise origins of the passage's name remain shrouded in legend. One story recounts the destruction of a large Native American war party in a sudden storm. Early French and American travelers' accounts contain similar stories. However, these early written accounts mention nothing of a war party per se—only that "there were a hundred Indians dashed against these rocks and killed in a single storm" or that a band of Indians travelling in canoes to a French trading post were resting on a rock shelf in the passage when a sudden storm trapped and drowned them between raging sea and ragged shore.

What we do know for certain is that the conflicting currents and unexpected winds of this treacherous, storm-swept channel have claimed many an unfortunate sailor, be they Native American brave in a canoe or merchant seaman on the decks of a sturdy schooner. Do the souls of those who've met an untimely demise traversing this infamous passage still wander the shores?

For the mariner navigating the busy harbors and coastline of the Peninsula, Death's Door passage was but one of many opportunities for a small mistake to lead to certain destruction of both ship and crew. The Peninsula's many bustling ports supplied the raw product needed to meet the insatiable appetite for lumber, stone, fish and other commodities in Great Lake cities such as Cleveland, Detroit, Chicago and Milwaukee. Safe navigation was paramount to economic success. Sailor and shipper alike demanded the construction of lighthouses to help steer clear of danger on a dark and stormy night. The Peninsula is dotted with these remote and lonely outposts, where stalwart lighthouse keepers and their families stood watch. Many of the keepers seem unable to abandon their assigned post even in death. Their presence is still felt at several of the Peninsula's dozen lighthouses. Are the lost keepers still tending their guiding lights?

The tales of unfortunate warriors, lost sailors and steadfast lighthouse keepers are but a few of the ghost stories woven into the fiber of Door County. Our mission at the Door County Maritime Museum is to preserve and celebrate the rich maritime heritage that shaped this remarkable peninsula. The many intriguing legends passed down from person to person

are as much a part of the personality of the county as its factual history. *Haunted Door County* is a wonderful collection of some of these fascinating and entertaining stories. Once you read this book, come visit us at the Maritime Museum to learn even more about the amazing cast of characters that forged Door County's history and make it what it is today—everything else you do in Door County will be even more special. Enjoy the book and come see us!

Bob Desh
Executive Director
Door County Maritime Museum

ACKNOWLEDGEMENTS

Few books are written in a vacuum. No matter how talented or imaginative an author might be, a story—be it fiction or nonfiction—can't truly come to life until it is infused with the energy of those who have either lived the tale or contributed to the spark in some small way. This book is no exception. Without the generous gifts of time and knowledge so graciously bestowed upon me by the people I interviewed, there would be no book.

For starters, I'd like to thank Bob Desh, executive director of the Door County Maritime Museum, and A.J. Frank, owner of Door County Trolley Tours. These two men have each pulled back the veil and brought the historic ghosts of Door County back to life for an enthralled audience. Thanks also to the kind folks who live and work on the peninsula and took time from their busy days to talk with a stranger about...well, even stranger things: Kevin Egan and Matt Falk-Lafay at Baileys Harbor Yacht Club Resort; Sonny Thomas of Sonny's Pizza; Doug Delaporte at Nelsen's Hall; Dennis Gordon of Blue Sky Harbor; Karen Tewes, great-niece of Jacob Schmitz; Joel and Mary Blahnik, caretakers at Chambers Island; the great folks at Shipwrecked Brew Pub; and the family of Elizabeth Ostrand.

On the home front, thanks to Kimberlee and Gretchen for sharing their experience. And I could not have written this manuscript without the support and kindness of Lorena Lopez, Dan Sumiec and Patrick Watts. You guys are the best! Of course, I'd especially like to thank my ever-patient and

very talented husband, Peter Rimsa. Pete is my photographer, Photoshop wiz, computer expert, sounding board and the guy who microwaves frozen dinners when I'm buried in a book.

Finally, I want to thank the readers, whom without, there would be no books. And that would be a very sad world indeed.

INTRODUCTION

It is wonderful that five thousand years have now elapsed since the creation of the world, and still it is undecided whether or not there has ever been an instance of the spirit of any person appearing after death. All argument is against it; but all belief is for it.
—Samuel Johnson

Unexplained noises. A sudden eerie chill that sends shivers down the spine. A glimpse of, well, *something* in our peripheral vision. Or maybe it's just the odd sensation of being watched when we know for certain that we're all alone. We've all had these experiences at some point, but what exactly does it mean? Oftentimes, things that go bump in the night have a perfectly logical explanation. But sometimes, there is nothing in the natural world that provides a satisfactory reason, and we are left to conclude that the experience was supernatural.

Human belief in ghosts goes back as far as recorded history, and archeological evidence shows that even preliterate cultures both worshipped and feared the spirit realm. But despite our mind-boggling scientific and technical advances, we still have no idea what any of it means. In many ways, we're no closer to understanding the phenomena than our primitive ancestors, who performed blood sacrifices and left offerings of grain to appease the angry spirits. And as a society, we are incredibly ambivalent about the topic.

We snicker with derision when a friend or coworker claims to have had a ghostly encounter, yet we spend countless hours glued to a television to watch the latest episode of *Ghost Hunters*. Most of our religions angrily deny the concept of earth-bound spirits and yet, rituals such as exorcism are written into the doctrines. Ask almost any scientist, and you are likely to be answered with rolling eyes. The topic, however, is so contentious that organizations such as The Committee for Skeptical Inquiry (CSI), made up of scientists and philosophers—even Nobel laureates—was formed to study and dispute paranormal claims. Seems like an awful lot of effort to disprove the unproven. And still, the debate rages on.

In simplest terms, a ghost is usually defined as the spirit of a deceased person, although there are plenty of reports of ghost animals and even inanimate objects such as ships and trains. We also have multiple terms to describe the...*ahem*...beings: ghosts, spirits, specters, phantoms, apparitions and poltergeists, to name a few. The labels are often used interchangeably, but for serious ghost buffs, there are subtle differences. Poltergeists, for example, are typically considered to be a manifestation of spirit or energy tied to a specific individual. These spirits are sometimes described as mischievous and sometimes threatening, and they act out in a rather physical manner— banging on doors, knocking over furniture and levitating Grandma's fine china. Because they are latched on to a living person, their hijinks only occur when that individual is present. Specters (sometimes spelled spectres) are usually considered threatening or horrific manifestations, but not all people use the word in this manner. In this book, the terms might vary for the sake of avoiding repetition.

But if ghosts do not really exist, then *what* exactly are we experiencing? It depends on whom you ask. Researchers have promoted theories that range from mass hallucinations to shifts in the earth's geomagnetic field to "infrasounds" (extremely low frequency sound waves that we can't hear, but that apparently fiddle with our senses somehow). Even carbon monoxide poisoning has been implicated as a factor. And of course, there are those who simply write off accounts of ghostly encounters as unadulterated lies.

In reality, it seems that many people don't believe in ghosts until he or she actually sees one. Then they are left in the untenable position of experiencing the psychological state known as cognitive dissonance. In layman's terms, they are confused as heck. This book makes no attempt to argue a case for the existence of wandering spirits, nor is it in any way intended to poke fun at the people who have had a close encounter of the strange kind. It is written

in the spirit (pun intended) of descriptive storytelling, and it chronicles the history behind the sightings and takes a stab at describing the testimony of some witnesses.

In any case, enjoy the stories and consider spending some time in the beautiful Wisconsin county that spawned them. Who knows what you might see or hear on the quiet back roads or rugged shoreline? Perhaps you'll head back home with a few stories of your own.

Part I

Haunted Ships and Lighthouses

Some places speak distinctly...Certain old houses demand to be haunted; certain coasts are set apart for shipwrecks.

—*Robert Louis Stevenson*

SHERWOOD POINT LIGHTHOUSE

The musical tinkling of fine china cups on saucers. The lilting cadences of a woman's demure laugh. These are soothing sounds that call to mind an elegant brunch in a stately old tearoom. Unfortunately, these sounds aren't quite so soothing when they echo late at night through a century-old lighthouse perched high on the rugged limestone cliffs edging the mouth of Sturgeon Bay. The Coast Guard personnel who tend to the property, however, know there is nothing to fear—it's just Minnie Hesh Cochems welcoming her guests. And although Minnie has been dead for more than eighty-five years, her hospitality has never wavered.

Sherwood Point Lighthouse first cast its beacon across the waves of Green Bay in October 1883, after a protracted legal battle over the title to the land. The site was originally settled in 1836 by Peter Sherwood and his wife, Clarissa, only the second white family to put down permanent roots in the area. At that time, the region was loosely populated by a transient handful of loggers, Indian traders, trappers and fishermen who came to claim a share of the seemingly endless natural resources. Sherwood's homestead stood on a steep outcropping of land just north of Sawyer Harbor, where the deep blue waters of Green Bay faded quietly into the shallow and marshy Sturgeon Bay. Life was hard in the untamed wilderness and, as time passed, Peter sold off bits of his land to younger and hardier newcomers. Upon his death in 1867, the remaining property transferred to Clarissa, but apparently no formal deeds existed and the boundaries were unclear.

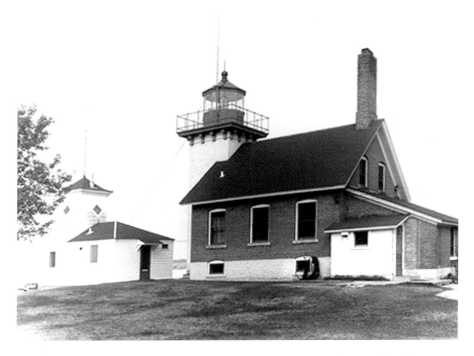

Minnie Hesh still greets guests at her beloved Sherwood Point Lighthouse, eighty-five years after her death.

A few years before Peter's death, Joseph Harris Sr., the publisher and founder of the *Door County Advocate* newspaper, began to dream about the possibility of a ship canal that would traverse the Door Peninsula. The young city of Sturgeon Bay was becoming a popular port along the busy shipping route from Chicago to Green Bay. The fast-growing but prairie-bound city of Chicago desperately needed all the fine timber and stone that the lumbering and quarrying settlements along Green Bay could provide. In return, the farmers and merchants of Chicago sent corn, wheat and consumer goods to the settlers up north in Wisconsin. It was a mutually beneficial relationship, but with one major flaw: schooners traveling the route had to pass through the dreaded *Porte des Mortes* (Death's Door) passage at the tip of the peninsula. This dangerous strait carried the dubious distinction of having the most freshwater shipwrecks of any place in the world. Strong and wildly unpredictable currents, rapidly shifting winds, unexpected shoals and a coastline formed entirely of jagged glacial stone threatened to pull the

wooden ships to a watery grave should they be foolhardy enough to venture into the foreboding passage.

Harris knew that the shallow and brackish bay that was his city's namesake dissected the Door Peninsula almost completely across its middle, with the exception of a little more than one mile of sandy and partly barren land on the eastern edge abutting Lake Michigan. In fact, most geologists believe that northern Door County was once an island that slowly connected itself to the mainland with a collection of silt and wave-tossed rocks. The Native Americans of the area had long paddled their canoes through Sturgeon Bay and made the short portage over land when crisscrossing between Lake Michigan and Green Bay. Harris realized that it would be a relatively simple and inexpensive engineering feat to create a ship canal by dredging the bay and digging a trench through the remaining sliver of land to connect the two great bodies of water. Not only would such a canal save ships from the necessity of sailing north through Death's Door, but it would also cut about two hundred miles off of the round trip from Chicago to Green Bay, saving perhaps several days at sea.

With a handful of backers and an apparently sincere desire to improve the safety of Great Lakes shipping, Harris went before Congress in 1870 with a sixteen-point document entitled "Proposed Ship Canal At Sturgeon Bay, Wisconsin: Reasons Why Congress Should Grant Lands To Aid In Its Construction." After pointing out the dangers of Death's Door and discussing the compelling trade reasons for the canal, Harris finished his appeal by stating, "the true remedy is for Congress to give the mariner...a safe channel that looks like nature intended should at some day be made through the portage at Sturgeon Bay." Congress agreed, and work on Harris's vision began in 1872. Unfortunately, the Depression of 1873 stalled the project, which didn't resume in earnest until 1877. Finally, on June 28, 1878, laborers tossed aside the last few shovels of dirt that separated the waters of Lake Michigan and Green Bay, and the canal was born. Although it would be several more years until the bay was dredged to a sufficient depth to accommodate the largest ships, 415 smaller ships made use of the new canal in its first full year of operation, a number that increased nearly tenfold once it was at full depth.

All the new ship traffic created an economic boom for the city of Sturgeon Bay, but it also highlighted the dire need for a lighthouse to guide ships safely into the bay. The Lighthouse Board chose the thirty-foot limestone bluff known as Sherwood Point as the most logical spot to build, but it seemed that neither Clarissa Sherwood nor her neighbors

could provide clear title to the property. After much bickering, the courts finally concluded that the specific parcel belonged to Mr. Elias Haines. Mr. Haines, however, saw an opportunity to profit greatly and demanded an outrageous sum for the land. When no agreement could be reached, the land was eventually condemned under legislation by the State of Wisconsin, and work on the new lighthouse began.

Unlike its counterparts on the Door Peninsula, Sherwood Point Lighthouse was built with red Detroit bricks, not the cream-colored Milwaukee bricks that distinguish the other light stations in the county. The lighthouse tender *Warrington* arrived from Michigan in May of 1883 with a twenty-man construction crew and the unfamiliar red bricks. When they finished in late September 1883, the new lighthouse boasted a one-and-a-half-story keeper's house, a tower that measured thirty-five feet from the base to the top of the lantern and a fourth-order Fresnel lens with a focal plane of sixty-one feet that cast its welcoming beacon up to fourteen miles across the water.

The first keeper was Henry Stanley, who took control in September of 1883. Henry and his wife Katherine had spent the previous fifteen years at Eagle Bluff lighthouse and were quite seasoned at the lonely and laborious work of tending a lighthouse. What Henry hadn't counted on, however, was the tricky and unreliable light mechanism that came with his new charge. Unlike other local lighthouses that displayed just a fixed white beacon, the Sherwood Point beacon was designed to also flash an intermittent red signal every minute. The bedeviled clockwork that operated the red panels was forever breaking down, despite frequent repairs by a Sturgeon Bay clockmaker and visits from the Lighthouse Board's district lampist, Mr. Crump. Henry kept a detailed log of his duties, and the recalcitrant light was a common topic.

In the fall of 1884, the aging Stanleys finally gained some relief. Katherine's twenty-one-year-old niece, Minnie Hesh, arrived from Brooklyn after the death of her parents. Minnie was an immediate and welcome assistant to her uncle—she kept log entries, climbed to the lantern room to struggle with the clockwork and helped with all the chores associated with keeping the beacon in top condition. Not long after moving in with her aunt and uncle, Minnie also attracted the eye of William Cochems, a local Sturgeon Bay boy who ran a hardware store in town. In August of 1889, Minnie and William married in a beautiful ceremony near the lighthouse. The newlyweds moved to a home in Sturgeon Bay, but Minnie continued to help her uncle at the station as much as possible.

In 1894, Henry turned seventy years old, and Katherine's health was poor. Years of running the rugged light had taken their toll, and the addition of a fog bell a few years earlier added to their workload. The mechanism that rang the bell needed to be wound by hand every four hours during the frequent foggy weather, a task that could mean life or death to a hapless mariner. Henry begged his district commander for an assistant keeper. By this time, William Cochem's hardware store had gone out of business in the Great Panic of 1893, and Henry convinced his superiors to hire William for the position. They agreed, and William and Minnie moved into Sherwood Point with the Stanleys. Just one year later, in late 1895, Henry passed away. Although William had precious little experience in running a lighthouse, the Lighthouse Board had no reason to doubt his abilities, and they promoted him to keeper of the light. In another surprise move, they appointed the ill and aging Katherine as assistant keeper. It was, in all likelihood, a maneuver to provide a pension of sorts for the elderly widow, whose years of loyalty had not gone unnoticed. In reality, however, it was Minnie who performed the

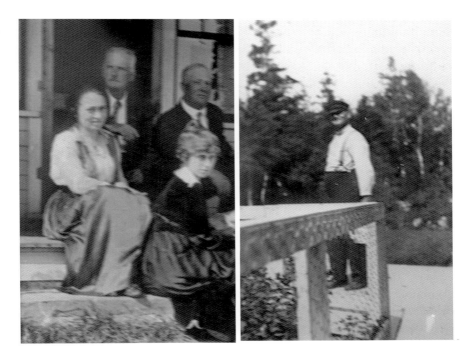

Minnie Hesh Cochems and her family are shown posing happily in these old photos.

duties of assistant in her much-loved lighthouse. Katherine finally retired in 1898 and moved into town. Minnie was officially appointed assistant keeper, a position she would hold for the remainder of her life.

During the many years that William and Minnie spent at Sherwood Point, the lighthouse was a happy place and a place to gather friends. The couple planted flowers and kept the property immaculate. The rigorous quarterly inspections performed by the district inspector rarely turned up anything amiss, due in large part to Minnie's meticulous care. Minnie loved to entertain and usually brought out her best china when friends visited her for tea. Sadly, in August of 1928, Minnie collapsed while getting out of bed and died of a massive heart attack. William was heartbroken and built a memorial to his beloved wife and companion in the garden that she had lovingly attended to. The bronze plaque remains to this day. And according to many witnesses, so does Minnie.

Although there are no records to indicate if William or his successors had any contact with Minnie after her death, she has made her presence known to dozens of visitors over the past few decades. In 1939, the Coast Guard absorbed the Lighthouse Bureau and, when the Sherwood Point light was finally automated in 1983, the station became a vacation retreat for active duty and retired Coast Guard members and their families. Over the years, countless stories have surfaced about Minnie's antics.

It often begins with the sound of soft footsteps on the stairs and that uncanny feeling that one is not alone. Because it is a towering old lighthouse on a windswept bluff, most people tell themselves it is the wind or perhaps some other perfectly rational explanation. Sometimes doors creak open, and a whisper of cool air enters the room. At this point, the wind is still a possible culprit. Then the gentle laugh echoes from a dark corner, and the guests know that it is Minnie coming to welcome them to Sherwood Point. Minnie is a friendly, if sometimes mischievous, presence. Logs kept by guests record dishes suddenly rattling on their own, unmade beds mysteriously made up and the echo of footsteps around the home.

One of the most famous documentations occurred when a young Coast Guardsman and his wife arrived at the station for a long-anticipated vacation. The couple was eager to see the sights around the peninsula and, after a hurried dinner, they rushed out, leaving dirty dishes on the table and in the sink. When they returned much later that evening, exhausted by the busy day, they decided to leave the mess for the morning. As soon as they fell into bed, however, they were startled by the sound of footsteps on the stairs. Next they heard a woman's laugh and the sound of dishes clattering. They were aware

of the legend of Minnie—indeed, she is quite well known amongst Coast Guard personnel—but hearing a ghost story and actually living it are two quite different things. The couple huddled in bed, torn between fascination and fear. Finally, the husband, summoning all the macho courage he could manage, shouted out, "Dammit Minnie! If you're going to make so much noise with the dishes, you could at least wash them!" To their surprise, the noises stopped. After a long while, they finally fell asleep. Perhaps they told themselves that they had imagined the whole thing after a long and busy first day of vacation. That is, until they awoke the next morning and stumbled into the kitchen for coffee. The kitchen was spotless—all the dinner dishes had been washed and put away, the counter and table wiped down and pristine—only one china teacup and saucer that had been removed from the cabinet was placed carefully at the table's edge.

Minnie's presence has been so well documented in Coast Guard logs that, in 2008, the Coast Guard supplied surveillance equipment and authorized the Northern Alliance of Paranormal Investigators to spend a weekend at the station and see what they could find. Although the team recorded the sound of an unidentified woman's voice talking and laughing, the audio mysteriously reformatted and disappeared when they tried to replay it. Video equipment also malfunctioned at crucial times. In the end, each of the eight investigators heard or felt Minnie's presence, but they were unable to capture any hard evidence. As usual, Minnie seems to be enjoying the last laugh.

CHAMBERS ISLAND LIGHTHOUSE

Chambers Island is the largest in a small cluster of islands dotting Green Bay, lying about seven miles due northwest of Fish Creek. It is an idyllic place, covered with deep green forests and boasting its own 350-acre body of water, Mackaysee Lake.

Mackaysee Lake also boasts two small islands of its own, odd bits of land that have the distinction of being islands in a lake on an island in a lake. Chambers got its name from Colonel Talbot Chambers, an army officer who was part of a military contingent that sailed past the island in 1816 en route to Green Bay to set up Fort Howard. Unfortunately, Colonel Chambers's illustrious career came to an embarrassing and sudden end in 1826, when he was court-martialed for drunkenness and various other charges. The island's name stuck nonetheless. Its true claim to fame, however, is that its position between coastlines naturally divides Green Bay into two shipping lanes: a rocky seven-mile wide strait known as Strawberry Channel along the Door Peninsula, and the wider (and safer) western passage along the Michigan and Wisconsin coastline.

Beginning in about the mid-1800s, the island served as a home to fishermen and lumbermen, who came to take advantage of its rich stands of virgin timber and bountiful waters. Life on the rugged outpost wasn't easy. During the warm months, the mainland could only be reached by sailing through the rocky and sometimes treacherous waters. During the winter, gathering supplies meant a sleigh ride across the vast frozen ice, which sometimes cracked and sent travelers to a freezing and watery doom. In

early spring and late fall, however, the inhabitants were cut off completely from the mainland by stubborn ice floes, making sailing impossible and failing to provide solid footing for horse or man. At those times, the residents were solely at the mercy of the elements and dependent upon the stores of food and other necessities that they had managed to stockpile during better times. Hunger and death always lurked in the shadows.

As mercantile ship traffic increased between Lake Michigan and Green Bay, the Lighthouse Board recognized the need for a beacon along the western shore of Chambers Island at the head of the channel and, in 1867, they purchased a forty-acre peninsula on the northwest edge of the island from Mr. Lewis Williams for a price of $250. The following year, a construction crew from Detroit came ashore from the steamer *Rocket* and started construction. The new lighthouse was a close replica of the nearby Eagle Bluff lighthouse, differing only in the shape of their towers. Although both are one-and-a-half-story structures of cream Milwaukee brick with attached towers, the tower at Eagle Bluff is square. Chambers Island tower has a square base but transitions to an octagonal upper portion. In October 1868, its fourth-order Fresnel lens cast its light for the first time, shining at a focal plane sixty-eight feet above the water.

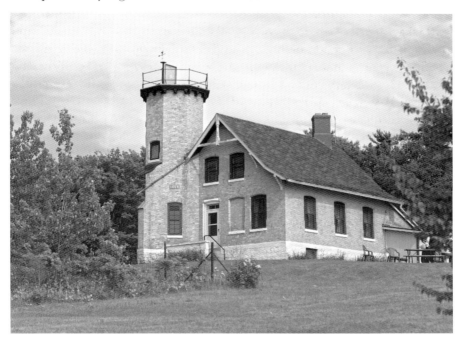

Chambers Island Lighthouse guides mariners safely through a Green Bay passage.

The first keeper was Lewis Williams, former owner of the land. Although Lewis was by trade a sawmill owner and had no experience in running a lighthouse, he had spent nearly twenty years on the island, and his sale of the land to the U.S. government was likely contingent upon his appointment to the post. He, his wife and their brood of eleven children moved into the station and stayed for twenty-one years, the longest of any keeper at the station. Williams took his job very seriously and kept the lighthouse in tip-top shape. Visitors spoke not only of his hospitality but also of his enormous strawberry patch that he tended to with pride. Given the rather plain and bland provisions supplied by the lighthouse tenders, the fresh strawberries must have provided some welcome dietary variety to the family and their guests. Indeed, Mrs. Williams's strawberry pies and preserves were nearly legendary.

When Williams finally retired in 1889, seven other keepers succeeded him until the station was automated in 1955. In 1958, the Coast Guard removed the lantern room, auctioned off the Fresnel lens and replaced the beacon with an automated electric light that was placed atop a short skeletal tower built above the old tower. This contraption lasted just a few years and, in 1961, a new ninety-seven foot skeletal tower topped with a battery-powered—now solar-powered—light was built closer to the shore. The old lighthouse, now abandoned, lapsed into disrepair. Finally, in 1976, the Coast Guard deeded the neglected property to the town of Gibraltar for use as a park. And that's where our ghost story begins.

The town immediately appointed Joel and Mary Blahnik as curators of the property. Joel has served as a U.S. Coast Guard boat captain since 1956, with more than twelve thousand excursions under his belt. He is also a world-renowned composer, conductor and music educator, as well as an advocate of Czech music. A Door County native, he and Mary were a natural choice to bring the old lighthouse to life. Each spring, as the ice floes slowly swept out to deeper waters and the bay became safe for boat travel, the Blahniks would pack up their home in Fish Creek for the summer and head for Chambers Island. It was backbreaking work to reverse the decline of the historic old property and create a lovely park, but it was a labor of love shared by the whole Blahnik family. And, as you might imagine given his vast accomplishments, Joel Blahnik is not a man prone to fanciful delusions.

On his first night as caretaker of the property, Joel was jolted awake by something. He and his nine-year-old son were nestled in sleeping bags in the first floor bedroom, exhausted by a hard day of clearing debris and opening the station for spring. As Joel listened, he heard the unmistakable

The ghost of keeper Lewis Williams sometimes hides tools under pillows and opens and closes doors in the keeper's quarters.

loud thumping of heavy footsteps descending the lantern room stairs. His mind whirled. To his knowledge, they were alone on the island. The sound was definitely human footfalls, however, not the pattering of an inquisitive raccoon or other wildlife. Joel tried to rouse his son in case the intruder meant harm, but the sleepy child merely grunted and rolled over. The footsteps continued down the hall and past the bedroom where Joel sat frozen, through the living room, down a small set of stairs and into the kitchen. He heard the kitchen door open and then close softly, its latch dropping into place with a distinctive click. Now fully awake, Joel jumped up and rushed out through the kitchen to confront the intruder, but he was greeted by just an empty yard, the wind rustling softly through Keeper Williams's abandoned strawberry patch. Unable to make sense of what he had just experienced, he vowed to put it out of his mind, and he did not mention it to Mary or anyone else. The rest of the summer was relatively uneventful, except for the occasional sense that someone was watching the family's movements.

The following spring, Joel returned to open the lighthouse. As he dozed off in a bunk that first night, he was once again jolted from his sleep. In an eerie reenactment of the previous year, he heard the familiar footsteps

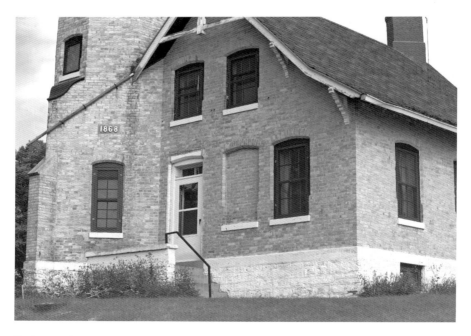

Each year, the long-departed keeper at Chambers Island Lighthouse helps open the station for the season.

trudging down the spiral lantern room staircase, through the dwelling and out the kitchen door toward the strawberry patch. Hearing the kitchen door click shut, he slipped on his shoes and followed the sounds outside. Again, he found only the relentless wind and a full moon. A shiver ran down his spine, but he felt a sudden surge of...what? Recognition, perhaps? In that moment, Joel had a sense that the visitor was Lewis Williams, handing off his precious charge for the summer. That thought was alternately comforting and frightening. Eventually, Joel shared his odd experiences with Mary, who at first scoffed at the idea. As time went on, however, the spirit became bolder and a little playful.

Joel was now used to the yearly "changing of the guard" as Keeper Williams exited the premises on every first night of the Blahniks' arrival, but Williams had taken to making his presence known in other ways and to other people as well. Things began to disappear, only to reappear later in odd places. One day, Joel was up on a ladder, repairing an old window. He set his screwdriver down on the window ledge but, when he reached for it a moment later, it was gone. He assumed it had rolled off and landed in the bushes below, but a later search of the area below the window came up empty. That night, when the family prepared for bed, they found the missing screwdriver carefully tucked under a pillow. Guests who spent the night at the station often reported a strong sense of being watched or the feeling of another's presence, and many were awakened when their beds shook as if being rattled by a pair of unseen hands.

After eleven years of living with the friendly spirit, Joel hosted a group of nuns from the nearby Holy Name Retreat House on a tour of the old beacon. When told about the ghost, one feisty nun marched over to the tower, placed her hands on the cream-colored brick and began to pray fervently for the spirit's release from its earthly bonds. After several minutes, she returned to the group and declared the ghost gone. To Joel's amazement, the presence seemed to vanish after the nun's visit. Whether it left permanently—or has just taken a brief sabbatical—remains to be seen. On an afternoon not too long ago, standing on the high bluff near the old strawberry patch, it was hard for a visitor to tell if the quiet murmuring was a mere trick of the omnipresent wind or the voice of a bygone keeper welcoming guests to his beloved beacon.

Pottawatomie Lighthouse

Rock Island is a small, heavily wooded isle off the northeast tip of Washington Island. Although it is uninhabited today, it was once a thriving community of Pottawatomie (sometimes spelled Potawatomie) Indians. The abundance of fish and small game served the settlement well, as did the relative protection from warring neighbors. Although Washington Island is only about one mile across the water, it was a dangerous passage by canoe when the wind whipped the waves into a frenzy. For the most part, the Potawatomies were safe and secure on their island paradise. They weren't always undisturbed, however, as European fur traders, explorers and missionaries had a habit of dropping by as they sailed past on the Grand Traverse route between upper Michigan and Green Bay. The tribe was friendly enough, though, and tolerated (if not welcomed) the strange white visitors. In fact, it appears that one of the first European settlements in all of Door County was a fishing village perched on the eastern shore of Rock Island. Those settlers eventually moved on to Washington Island, leaving behind some graves (still visible today) just to the north of the outpost, now long gone.

In the early 1800s, ship traffic increased dramatically through the Rock Island passage as traders and pioneers moved farther into the Wisconsin territory, especially the area around Green Bay. In 1832, a large consortium of Detroit merchants, ship owners and investors petitioned Congress for a lighthouse to mark the rocky passage through Green Bay waters. The money was appropriated in 1834, but work didn't begin for two more years.

Finally, in 1837, the Pottawatomie light was completed on a 137-foot-high, windswept bluff on the northwestern corner of the island. It had the distinction of being the first lighthouse on Lake Michigan and also the first in the new state of Wisconsin.

Unfortunately, the lighthouse was overdue, over budget and very poorly constructed. The mortar that held the bricks and stone together was improperly mixed, and it allowed water to ooze through every crack and crevice. The first keeper, David E. Corbin, complained of plaster falling from the walls and ceiling and of a perpetual relentless dampness that chilled both body and soul. Corbin perhaps had another reason to feel gloomy. He was a bachelor that lived alone on the sparsely populated island, with just a pet dog and his loyal horse, Jock, for company. Although he had occasional visits from the handful of fishermen and their families living on the other side of the island, it was still a lonely life. Corbin threw himself into his work, cutting a road across the land and clearing acres of forest to enhance his light's visibility.

During a visit from Lighthouse Inspector John McReynolds in 1845, Corbin mentioned his terrible unceasing loneliness. McReynolds made two decisions to help improve Corbin's life: he granted the keeper a twenty-day leave of absence to "go out and find a wife," and he requested that Corbin be given a raise of $50 per year. Sadly, neither came to fruition. Corbin did take the leave but was unable to procure a soul mate in such a short span of time, and his raise was denied by the auditor of the treasury, Stephan Pleasanton. When McReynolds returned the following year, he was frustrated that nothing had changed. He appealed to Pleasanton on Corbin's behalf, suggesting that the extra $50 would help ease Corbin's emotional distress. Once again, Pleasanton declined the request.

At some point, Corbin did find companionship, if not additional pay. The census of 1850 lists six occupants at the station: Corbin, a woman named Catharine Storce, her three children and a laborer named William Kingsley. There is no source that describes the relationship between Corbin and the others, but at least he was no longer alone. Sadly, he wouldn't have much time to enjoy his new housemates. The following winter was exceptionally cold and long and, by spring, the hardworking keeper was feeling weak and ill. His health continued to decline, and he passed away in December of 1852 at the age of fifty-seven. His friends buried him in a small cemetery to the south of his beloved lighthouse. His grave remained unmarked for 150 years, until 2002, when a nonprofit organization named Friends of Rock Island (FORI) erected a beautiful headstone to commemorate his selfless service.

After Corbin's demise, four other keepers passed through the post in a six-year period, but they apparently found the gloom and dampness was untenable. Finally, in 1858, the Lighthouse Board stepped in and razed the entire station and built an entirely new and greatly improved one in its stead. The new station, however, did not greatly improve the keepers' length of service. From the time it was built until it was automated in 1946, a dozen more keepers served at the lighthouse. Only two—William Betts (1870–1886) and Edward Cornell (1911–1928)—occupied the lighthouse longer than Corbin.

In 1965, the Wisconsin Department of Natural Resources (DNR) purchased most of the land on Rock Island from the estate of Chester Thordarson, a wealthy Chicago businessman who owned about 775 of the island's 975 acres. Thordarson had used the land as a summer estate, and he built a magnificent Viking-styled stone boathouse

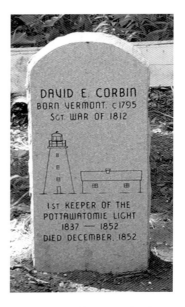

David Corbin finally received a proper monument 150 years after his death. The shy bachelor still walks the grounds of his beloved lighthouse.

decorated with symbols from the Norse Runic alphabet. He was a brilliant man, and the grand hall above the boathouse contained his collection of 11,000 rare books, which eventually became the basis for a collection at the University of Wisconsin. The DNR turned the land into a state park, and the boathouse became the park's splendid visitor's center.

Unfortunately, Pottawatomie Lighthouse didn't fare quite as well during the mid-twentieth century. After the light was automated, the station was largely abandoned and left to fall into disrepair. The Coast Guard removed the lantern room and replaced the beacon with a steel skeletal tower in 1988. It wasn't until 1994, when FORI members began to push for support to renovate and restore the old station that the lighthouse and its grounds began to come back to life—both figuratively and literally! In fact, there are so many different ghost stories on the tiny island that it's hard to pin down the likely spirit suspects. Perhaps the multiple encounters are due to the fact that there are simply more people on the island now. In 2004, the old light was officially renamed and dedicated as the Pottawatomie Lighthouse Museum, and volunteer docents, working in shifts, began staying on the property from

Memorial Day to Columbus Day in order to offer tours to island visitors. Through the marvelous work of FORI, more people than ever are able to witness the history and the phenomenal natural beauty of Rock Island. And some visitors, it seems, witness more than they bargain for.

David Corbin, for example, seems quite pleased with the renovations. Guests over the years have reported hearing ghostly footsteps and doors opening and closing in the old light station, and some have glimpsed a shadowy male figure in the lantern room at various times. It is never a clear sighting but, rather, that sideways perception—that sudden unease, as something flickers beyond the periphery of your vision. It is not a threatening presence. In fact, it seems as though the spirit moves through the lighthouse in a perpetual state of watchfulness, eternally protective of the brave mariners that pass in the night. And in death, David seems to have more company than he ever had in life, for he is not the only spiritual presence on the island.

As visitors walk the grounds, it's common for them to hear the joyful laughter of playful children. The giggles and squeals tumble across the land, rising and falling with the boom of the nearby surf, but the children are nowhere to be seen. As the curious tourist follows the happy sounds toward the center of the island, he will suddenly realize that he has stumbled into a small, neatly kept cemetery with a handful of ancient graves. As the echoes

Pottawatomie Lighthouse has been restored to look almost exactly as it did when its keeper, David Corbin, was alive. Corbin is rumored to still roam the property.

of laughter die away, the guest will realize that he is looking at the gravestones of children: that of four-year-old Rosalina Miner, who passed away April 25, 1853, and her three-month-old sister, Cecelia, who died just three weeks later. Sadly, they are not the only innocents buried on the island. Near David Corbin's grave on the north end of the island is the final resting place of the Newman Curtis family, including their young son and their eight-year-old daughter named Jerusha. The girl and her parents drowned in the fall of 1853, just a few months after the boy died of unknown causes. And on the south shore of the island, another small cemetery holds the body of Francis William Boon, the five-year-old son of John and Henrietta Boon. Whatever suffering these young pioneers experienced in life has gone unrecorded, and present-day witnesses attest to hearing the sounds of carefree merriment floating across the island.

Of course, we can only guess at the actual source of all the noises and apparitions. Scores of Native Americans lived and died on these shores, and few of the graves are actually marked. The simple wooden crosses or nondescript fieldstones that perhaps once served as gravestones have long ago crumbled to dust or washed away in the angry surf. Most of the deceased's bodies were buried on the south shore, in an area that was once a sand-covered beach. It is now overgrown with trees, and many people have observed shadows moving through the area at dusk, flickering lights and the sound of murmuring voices and soft chants. Indeed, although modern travel guides claim that Rock Island has no permanent residents, it seems that they must only be referring to *living* residents. Some of those who have long since passed into another realm apparently still call the island their home, and they are only too happy to offer a spine-chilling welcome to visitors.

THE PHANTOM SHIP *LE GRIFFON*

The shores of Door County and its surrounding islands have long been renowned for their wealth of natural resources. Fish, fur, timber and stone were once currency, and eager fortune hunters came from far and wide to grab a share of the bounty. In fact, the first explorers to visit the peninsula were mostly fur traders and missionaries from the French provinces in Canada. Frequently, they traveled together—one with a goal of conquering the Native Americans' spirits, and the other with a goal of conquering their lands. Such was the case in 1679, when French explorer Robert de LaSalle and Father Louis Hennepin set out with a crew of thirty-two men aboard de LaSalle's fabulous "floating fort," *Le Griffon*. LaSalle planned a busy itinerary, which included gathering a fortune in furs, paying off his creditors, building forts and exploring the Mississippi. And with *Le Griffon* at his command, he had the means to achieve these lofty goals.

Prior to the late 1600s, the typical boat used on the Great Lakes was the canoe. A canoe could be either made out of birch bark or a hollowed-out tree. Lake canoes were often large—sometimes up to thirty-five feet in length—but the primary method of propulsion was oars. These primitive boats didn't allow for much protection, speed or cargo room. LaSalle knew that if he wanted to rule the fur trade and its riches, he would need a better boat. And so, in the winter of 1679, he and his men began construction of a grand new ship that was designed to outstrip any competition.

After a harrowing and trouble-filled start, which included the loss of their supply ship, LaSalle and his crew finally laid the keel in January 1679, at the

mouth of Cayuga Creek, near Niagara in western New York. Soon thereafter, LaSalle departed on foot for Fort Frontenac in an attempt to appease his creditors and gather more supplies. He left his trusted lieutenant Henri de Tonti and Father Hennepin behind to oversee the construction. Work moved quickly, but the winter was harsh, and the workmen suffered from hunger and cold. The crew muttered darkly about mutiny. To make matters worse, some of LaSalle's competitors had whispered false rumors to the local Seneca tribe that the new ship was a warship, bent on destruction and conquest. Tonti heard that it would be attacked and burned before launch. Not wanting to wait around and risk an ambush, Tonti and Hennepin launched the partially completed ship early, before the sails were rigged and final construction was completed. They did have some cannons aboard, which they ceremoniously fired upon launch. The thunderous roar of gunpowder struck fear and awe into the hearts of the natives and quelled any thoughts of an uprising.

Finally, anchored safely offshore, Tonti and the crew finished the final rigging and provisioning. *Le Griffon* was magnificent. The completed ship was a forty-five-ton barque, fitted with three masts (although that number is in dispute—some sources say only one or two) and several square sails. Seven cannons flanked its rails, and a carved figure of its mythical namesake rode proudly on the bowsprit, warding off any potential enemies. When LaSalle returned and the ship embarked on its maiden journey, it became the first full-sized sailing ship on the Great Lakes and a precursor to modern commercial navigation.

After a tortuous journey through Lake Erie, Lake St. Clair and up through Lake Huron, the voyagers finally arrived safely at Mackinac Island in late August. They were greeted by an enthusiastic group of Huron Indians, who turned out in birch-bark canoes by the hundreds to surround and examine the "giant canoe" that had sailed to their shore. LaSalle caught up with some deserters from his previous crew on the island but apparently lost a few current crew members, who had had enough of the arduous expedition. He left Tonti behind to deal with the personnel issues, with plans to rendezvous later, while he and the remaining crew sailed on to Washington Island at the head of Green Bay. There, a great number of Potawatomi tribesmen awaited him, including their revered head chief, Onanguissé. LaSalle and Onanguissé had encountered each other several times previously, and they had a great deal of respect and affection for each other. By all accounts, the visit was a resounding success. The friendly Potawatomi had hunted more than twelve thousand pounds of fur, and LaSalle had important and practical items such as fishhooks, guns, gunpowder, knives, kettles and other

Explorer Robert LaSalle's beautiful *Le Griffon* sailed from Washington Harbor, never to be seen again. Indian folklore says the ship "sailed through a crack in the ice."

tools, as well as some fancy adornments such as beads and brightly colored coats, to offer in trade.

On September 18, 1679, *Le Griffon* sailed back toward Mackinac Island, heavily laden with its valuable cargo. LaSalle decided to remain behind with a small crew and continue exploration along the Lake Michigan coast. The ship was to sail to Niagara for supplies and then return for LaSalle and the others so that it could continue southward. The last day the crew saw the ship, Father Hennepin described in a letter that the day had a "light and favorable wind," and noted that the crew fired a single cannon shot in farewell as it sailed north from Washington Harbor. *Le Griffon* was never seen again.

There are plenty of theories regarding the ship's fate. Some claim that the vessel simply went down in a sudden fierce storm that hit the next day, which brought towering waves and high winds. Others blame the captain and

The last known sighting of the grand ship *Le Griffon* was when it sailed from Washington Harbor, on Washington Island's northern coast.

crew with scuttling the ship and making off with the fortune in furs. Others blame Ottawa and Huron tribesmen, who they claim murdered the crew and burned the boat. There is even a supernatural explanation: Metiomek, an Iroquois Indian prophet, believed that the giant ship was an affront to the Great Spirit, and he placed a solemn curse upon it. When it failed to return, the Indians whispered that it had "sailed through a crack in the ice."

In any case, nearly 350 years after its disappearance, *Le Griffon* remains a mystery. It has been called the "holy grail" of Great Lakes shipwrecks, and searchers believe that it might remain preserved in the cold deep fresh waters of Lake Michigan. In 2001, a team of divers that comprise the Great Lakes Exploration Group came across what they believed to be the bowsprit from the legendary ship buried in the sand and silt off northwest Michigan, but they were quickly embroiled in a legal morass over ownership to the site. In July 2010, they announced a partnership between their group, the state of Michigan and the Republic of France to bring in archeologists and researchers to determine if indeed *Le Griffon* has been found at last. As of this writing, there is no definitive answer. The great ship, however, seems unfettered by the icy depths and continues its ghostly voyage through foggy Lake Michigan nights.

Over the centuries, there have been innumerable accounts of a sailing ship with a tall mast suddenly appearing out of the gloom. When other

sailors approach to render aid, the vessel disappears into the storm-tossed waves. Indian legends mention a ghostly ship gliding silently along the shores at night before fading into a mist. Perhaps the most popular modern story was advanced by author Geri Rider, who details a frightening encounter in Death's Door. According to Rider, a small cruiser named the *Kelly* departed from Rowley's Bay on the Lake Michigan coastline one late July afternoon. The two couples aboard the boat had spent the day exploring the Mink River estuary and Newport State Park and were headed back to their lodging in Gills Rock on the Green Bay side of the peninsula. The lake was much rougher than they expected after leaving the protected bay, and the small boat struggled to make progress against the heavy waves. Their tension grew as the sun dropped lower in the sky, casting dark shadows across the water.

By the time they entered the dangerous strait between the mainland and Washington Island, night had fallen, and the wind whipped the waves into a frenzy. They found themselves trapped in the maelstrom of Death's Door, barely making headway as their boat pitched blindly through the passage. Now terrified, the four searched frantically for visual cues to pinpoint their position. Suddenly, as their boat was lifted on the crest of a wave, one of the women spotted the lights from a very large ship dead ahead. She shouted to the others, but they had now dropped into the wave's trough and no one could see a thing. It was unlikely that a pleasure craft would be out in this storm, so it seemed that the only possible large vessel on the lake would be the Washington Island Ferry in its trek across the water. It was too late for the ferry to be running, however, and the men feared that the woman had actually seen lights onshore, meaning they might be in danger of running aground on the rocky coastline. As the next wave scooped up the small motorboat and lifted it high on the water, all four found themselves staring straight ahead at the massive rough-hewn wood side of an ancient three-masted sailing ship. It silently glided past their bow, its square sails flapping noiselessly in the wind and, for a brief moment, it was silhouetted against the hazy moon. The *Kelly* then dropped once again into a trough and, when it crested, the ghostly ship had disappeared.

Now thoroughly rattled, the boaters nearly cried in relief at the sight of the lights at Gills Rock. Once they had safely docked, the foursome struggled to come to terms with what they had seen. Was it *Le Griffon?* Was it a hallucination brought on by fear and stress? Although we will never know the answer, four vacationers left the Door Peninsula with a memory that will haunt them forever.

THE WRECK OF THE *VAN VALKENBURG*

As mariners know all too well, Lake Michigan can be an unpredictable mistress: calm and peaceful one moment and whipped into a violent fury the next. Such was the case in autumn of 1881 when the crew of the *D.A. Van Valkenburg* departed Chicago with a load of 30,000 bushels of corn en route to Buffalo, New York. The 539-ton barque carried a crew of nine as it left the dock and pointed northeast for the first leg of its trip, crossing the center of Lake Michigan and moving toward Mackinac Island. The mid-September weather was mild and pleasant, with a light wind filling the sails as the ship glided along its course. Once fully underway, the crew probably had some time to enjoy the warm sunlight as the gentle spray of cool lake water danced upon the deck.

However, as the sturdy ship sailed north into Wisconsin waters, everything began to change. The sun slipped behind dark, brooding clouds, and the gentle wind began to howl with a sudden ferocity. The crewmen soon found themselves trapped in the teeth of a sudden and vicious gale. What began as a peaceful trip had morphed into a deadly struggle for survival. While the wind clawed angrily at the sails, the ship was tossed about like a cork in the waves, making any attempt at steering a course nearly impossible. For two whole days and long nights, the crew struggled to keep its vessel afloat. Finally, as darkness gripped the skies on the second night, the ship shuddered and groaned with an awful sound as the waves tossed it onto a shallow reef.

The exhausted crew believed it was near Michigan's Manitou Islands but, in reality, the storm had swept the ship off course fifty miles to the west, and

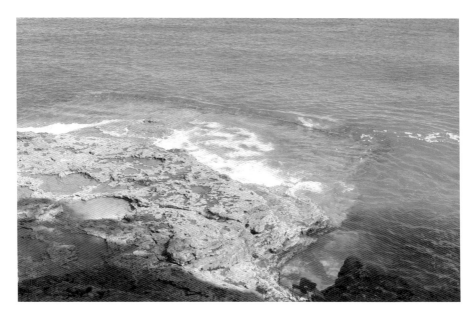

In stormy weather and high seas, the rocky ledges that surround the coastline are hidden and deadly for ships that venture too close.

it had foundered on the rocks of the Door Peninsula. Through the driving rain and fog, the crew members could barely make out the silhouette of land just to the west. It seemed they were nearly ashore, but the roaring waves that separated them from safety looked insurmountable. They hoped to stay with the grounded ship, at least until daylight granted them some vision, but the angry whitecaps splintered the decks out from under them. With no other choice, the men dove into the churning water and started to swim for land. The distance was short, but the waves relentless. To add to their misery, the shoreline itself was just a series of craggy limestone cliffs with nothing but a few aged and twisted cedars to offer a handhold. Each time, their fingers would reach out to grasp the slippery rocks, another wave would lift them and toss them cruelly onto the jagged ledges or pull them farther out into the roiling surf. One by one, beaten by exhaustion or pummeled into unconsciousness, the sailors slipped under the lethal waves.

Only one would survive. A scrappy young man by the name of Thomas Breen managed to cling tenaciously to a cliff despite the water clawing at his legs. Slowly and painfully, he dragged himself up the nearly vertical face of the bluff until he collapsed unconscious at the top. When morning came, the battered and bloody sailor slowly regained consciousness and

recalled the horror of the previous night. Despite his injuries, he pulled himself to his feet and began to limp painfully to the nearby settlement of Jacksonport to look for help. The townsfolk immediately rushed to the site in hopes of rescuing other survivors, but there were none. Four bodies bobbed in the now-docile surf, but the other four were never found and were presumed to have been swept into the lake's cold depths. To this day, the wooden decking of the doomed ship is still visible in shallow water, just a short distance from shore. According to some, the tortured sailors can still be seen and heard some nights, struggling in vain for the safety of the elusive shore.

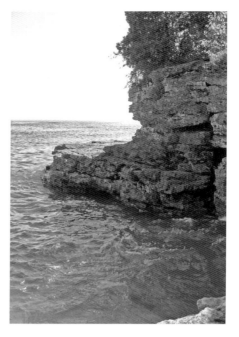

The crewmen of the *Van Valkenburg* were dashed against these sheer rock cliffs when their ship foundered. Only one would survive to tell the tale.

Standing on the precipice at Cave Point and observing the mighty power of the lake strikes a deep primordial fear in some folks, even on calm and sunny days. That fear is palpable to anyone when, after dark, the wind begins to howl through the cliffs like a banshee from hell, and the breakers below crash onto the rocky ledge and explode into geysers of water that shoot angrily into the moonlit sky. A visitor's hair might stand on end as the ungodly echoes boom across the shore, mingled with what might be mistaken as a cry of someone drowning. Perhaps it is the plaintive call of a gull flitting across the waves, but the rise and fall of the sounds seem distinctly un-birdlike. Some have seen shadows in the surf, indistinct forms that look vaguely human but, of course no human would risk the certain death of entering such deadly waters, especially at night. The shadows clutch at the base of the cliff, then tumble over the waves and out toward open water. And these are not the only encounters.

One young couple, tired after a busy day of sightseeing, was driving south on Highway 57 one night from Jacksonport toward their rental cabin near Sturgeon Bay. The narrow two-lane road was dark and winding, and thick

stands of evergreen, birch and maple suspended in a canopy over the road. Only the arc of their headlights and a pale glimmering moon offered any illumination. Suddenly, as they rounded a bend, their headlights fell on a young man staggering toward them along the shoulder. At first, they assumed they were approaching a drunken reveler, unsteady after an evening of too many Lienenkugels. As they drew closer, however, they realized something wasn't right. The tattered clothes he wore were from another era, and he appeared to be drenched, although it hadn't rained in days. They slowed the car and saw that the man was covered with blood, his face battered and bruised. Frightened and unsure, they wanted to help but didn't know what danger they might be getting involved in. The woman hesitantly rolled down the car window and called out to the man, "Are you okay? Do you want us to call for help?" The figure slowly turned and looked at them with sad eyes. It was then that they realized that the moonlight was actually shining through his silhouette, as if he was transparent. And just as suddenly, he was gone.

The frightened pair drove off quickly, unsure of what they'd just seen. After they had a chance to calm down, they decided to turn around and go back. Perhaps there had been a horrible accident, and they would never

Remnants of shipwrecks still line Door County's rocky coastline, accounting for many of the ghostly mariners rumored to walk these shores.

The *Van Valkenburg* was lost at Cave Point, not far north of the Sturgeon Bay Ship Canal.

forgive themselves if they had left an injured victim to die on the roadway because of a trick of the eye. They drove slowly with their high beams on, all the way to Jacksonport and beyond, but there was nothing to see. Once again they turned south, even stopping at the bend in the road where they had seen the apparition. There were no footprints in the soft sandy shoulder, and no indication that anyone had walked that path recently. Only the wind whistling softly through the trees. They drove the rest of the way to their cabin in silence. They had never heard of the *Van Valkenburg* and didn't know that an ancient wreck laid in the turbulent waters, just a stone's throw to the east of the bend in the road. Separated by more than a hundred years, they hadn't known Thomas Breen and couldn't have offered true assistance. Perhaps that awareness accounts for the deep sadness in his eyes. In any case, it appears that on some moonlit nights, the loyal sailor still trudges painfully toward Jacksonport in order to seek help for his drowning mates.

THE *HACKLEY*'S LAST PASSENGERS

G etting from one town to the next in Door County in 1903 was not easy. There were no cars or paved roads, and horse-drawn carriages struggled over rutted, rocky paths and swampy marshes. To reach larger cities, such as Sturgeon Bay or Green Bay, could mean a full day or more of travel. If one had the means, however, travel by boat was relatively fast and reasonably comfortable.

And that's exactly what spurred Fish Creek resident Captain Joseph Vorous to start up the Fish Creek Transportation Company in the spring of that year. He brought in some partners—Henry Robertoy, Orin Rowin and Edgar Thorp—and together they raised the $3,000 necessary to buy a proper ship. It was the *Erie L. Hackley*, a seventy-nine-foot long wooden steamer that had spent the previous twenty years hauling passengers and freight on the Manitou Island route. It was a sturdy ship, albeit not a fancy or modern one. The partners hoped to expand someday, but the *Hackley* would do just fine until the business got off the ground.

The inaugural route departed daily from Sturgeon Bay and headed northwest across Green Bay to Menominee, Michigan, a distance of about nineteen miles. From Menominee, they would steam the sixteen miles back east across the bay to Egg Harbor, then north to Fish Creek and finally northward toward Washington Island. The schedule was flexible and, if a merchant had freight in say, Sister Bay, the *Hackley* could detour to accommodate. The little steamship was quickly dubbed with the slightly derisive nickname of "the Egg Harbor Express," a reference to the thirty-

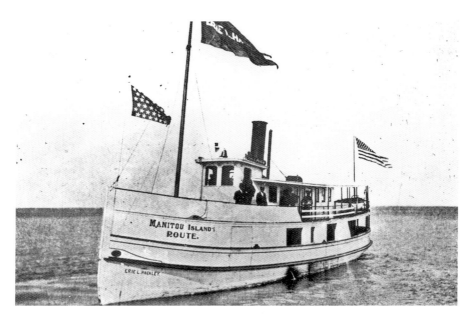

The *Erie L. Hackley* went down in a sudden storm, taking many of Fish Creek's prominent residents to their grave.

five-mile round trip back and forth across the bay that locals had to endure when traveling between Sturgeon Bay and Egg Harbor. It still beat the long stagecoach rides, however, so the nickname wasn't entirely without a measure of affection. By late summer, the Fish Creek Transportation Company had established a steady trade, and the *Hackley* was a familiar sight as it chugged steadily across the waves.

Autumn of 1903 was not as kind. The trouble started in early September, when the ship was laid up with a damaged propeller shaft. Two weeks later, it was put out of service yet again when the boiler needed repair and inspection. Once declared seaworthy, it sat at dock for a few more days due to intense early fall winds. On the morning of Saturday, October 3, the *Hackley* set off on its usual route from Sturgeon Bay. Perhaps due to built-up demand from the time during which the steamer was out of commission, it carried an exceptionally large cargo of freight along with its typical passenger traffic. The trip from the base of the bay to Menominee was rough, with a strong southwest wind whipping the water into churning whitecaps. At the Michigan port, they exchanged some freight and passengers and set out for Egg Harbor about 5:45 p.m. There were nineteen people onboard, including Captain Vorous; fireman Blaine McSweeney; partner and engineer

Orin Rowin; partner Henry Robertoy; purser Frank Blakefield; deckhand Freeman Thorp; cook Carl Pelkey; and Lawrence Barringer and his sister Edna, all from Fish Creek. Also onboard were two young sisters from Egg Harbor, Ethel and Edna Vincent, and a handful of passengers from a variety of small towns around the area.

Co-owner Edgar Thorp was in Menominee that day and planned to make the trip back to Fish Creek, but he felt strangely uneasy. The wind had died down considerably, but the sky was still dark and threatening. The weather forecast called for a cold front to move through the region, shifting winds to the northwest and creating possible squalls, but Captain Vorous wasn't particularly concerned. His ship was sturdy, and he was certain they could make port in Egg Harbor before the weather deteriorated any further. Thorp, however, couldn't shake his feeling of dread and, at the last moment, he made a sudden decision to remain in Menominee. Oddly— just the night before—Edgar's brother, Roy Thorp, had experienced a terrible nightmare. In this dream, he saw the *Hackley* embattled by a vicious storm that caused the boat to go down, drowning everyone aboard. Roy thought of telephoning Edgar and pleading with him to stay ashore but, in the cold light of day, his dream seemed rather childlike and silly. Perhaps his brotherly concern somehow reached its target anyway, because something caused Edgar's trepidation and prevented him from getting onboard. Unfortunately, that fear did not prevent the captain or the other passengers from attempting the passage.

There is also a frequently told story that Captain Vorous's sister Grace wanted to make the trip, but Vorous wouldn't let her come along due to the rough weather. Although it adds another eerie element to the final voyage, it isn't true. In reality, Grace was hospitalized in Menominee at the time and wasn't capable of traveling that Saturday. She did, however, have plans to return to Fish Creek later that week. And so, as the late afternoon sun dipped below the horizon, the *Hackley* steamed away from the Menominee dock.

The start of the trip was uneventful, though quite rough. The ship pitched fitfully in the waves as it steamed eastward. The captain and crew were each keeping a wary eye on the northern skies, watching closely for the predicted line of squalls, when suddenly the wind picked up with a hellish fury. To their surprise, the gale was coming from the southwest, not the northwest as predicted. Captain Vorous immediately turned to port, apparently hoping to head into the waves and wind instead of being battered broadside. Some historians think he was trying to return to Menominee, but Blakefield believed the captain was trying to reach the lee side of Green Island, about

one mile south of the ship's position. In any case, the *Hackley* dropped into a trough between the giant waves, the propeller spinning uselessly against the almost supernatural power of the water. Blakefield ran to the pilot's house to help Vorous in his battle to right the steamer, which was now listing dangerously from the storm's assault. The passengers raced for the deck to grab life preservers, but it was too late.

A monstrous surge broke over the ship, pouring thousands of gallons of water into the hull. The pilot house tore loose, and the next wave clawed over the *Hackley* and dragged it to the bottom of the bay, 110 feet below. Survivors later estimated that the foundering had occurred in less than two minutes. Although many of the victims drowned immediately, others were pitched into the dark and frigid maelstrom. They clung to bits of floating debris while the wind howled mercilessly throughout the night. By morning, only eight of the nineteen people who had begun the voyage were still alive. The prospects for the survivors were grim, however, as they bobbed helplessly on scraps of shattered decking. They were weak and exhausted and suffering from exposure in the icy water. Although a search had begun for the missing steamer, there was no way of knowing where or when she had foundered, and rescuers were unlikely to arrive in time. Miraculously, a customer aboard the passing steamer *Sheboygan* noticed something in the waves and called it to Captain Asa Johnson's attention. The *Sheboygan* was not part of the search and was unaware of the *Hackley*'s plight, but the ship was running off course itself and behind schedule due to the previous night's storm. Captain Johnson had kept his ship in the safety of Washington Harbor overnight and was only now resuming his route since the worst of the storm had passed.

At first, Johnson and his second mate believed that the passenger was simply seeing logs adrift in the bay, but the captain fetched his binoculars for a closer look. To his horror, he saw human forms adrift on rafts of debris and immediately swung his ship around and steamed to the rescue. In the final tally, four passengers and four crewmen survived the wreck, but the eleven victims represented the greatest single loss of life on Green Bay and left the town of Fish Creek and some surrounding communities bereft.

Freeman Thorp and Captain Vorous have graves in the Pioneer Cemetery in Fish Creek, as well as many of Thorp's relatives, including his father Jacob. It's unclear, however, if the graves actually hold any bodies. Freeman apparently did survive the initial sinking but died of exposure during the night. Captain Vorous is believed to have gone down with his ship. Most of the news accounts of the time claim that no bodies were recovered, so it's likely that the gravesites serve as memorials rather than actual interments.

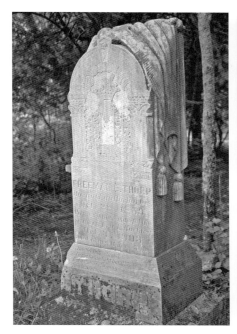 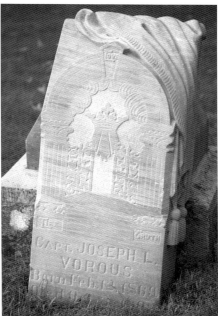

Above, left: Freeman Thorp drowned in the sinking of the *Hackley*, but he reportedly still walks the roads of Fish Creek.

Above, right: Captain Joseph Vorous was in command of the *Hackley* on its final tragic voyage. His body went down with the ship, but his spirit is believed to wander along the shoreline and through the graveyard in Peninsula State Park.

Although the wreck site was apparently discovered a few weeks after the incident by the tugboats *Leona R.* and the *Pilgrim*, which used grappling hooks and heavy chains to drag the bottom of the bay, the wreck rested in waters too deep to explore at the time. The tugs only managed to dredge up a woman's scarf and some other personal items believed to belong to passengers of the ill-fated ship, and the location was forgotten as years went by.

In June 1980, seventy-seven years after the *Hackley* went down, divers rediscovered the site. Using modern equipment, they were able to retrieve two sets of skeletal remains and bring them to the surface. Unfortunately, no one could determine exactly who they were, and no relatives stepped forward to pay the expenses of burying a potential stranger. The remains languished at a local mortuary for four years until the manager of Bayside Cemetery in Sturgeon Bay heard the odd tale. He immediately offered a burial plot and called on volunteers to step up. In May of 1986, more

than eighty years after the sinking, the unknown victims received a proper funeral, complete with a turn-of-the-century horse-drawn hearse, handmade coffins, flowers and a tombstone. It seems, however, that the belated respects have done little to soothe the tortured spirits of the *Hackley*.

Old time mariners still avoid the waters to the north of Green Island, claiming that odd things can sometimes be seen and heard on that stretch of water. Of course, the tough and weathered captains are mostly unwilling to admit ghostly encounters have occurred, so they offer sparse details. On land, however, those sightings have been frequent enough to send a chill up the spines of a larger audience. There have been numerous reports of wandering spirits, especially in the vicinity of Pioneer Cemetery. Some people claim that shadowy figures drift restlessly from the shoreline to the cemetery whenever strong autumn winds toss the waves into whitecaps. Others have heard mournful screams along the rocks that echo across the water before they slowly fade in the breeze. Naysayers will claim it's just the sounds of gulls as they float through the foggy nighttime mists, but Fish Creek natives know better; they have all heard the tale of the *Hackley*, and many have lived their lives knowing that a relative, neighbor or friend went down with the ill-fated ship. Perhaps it even gives some folks slight comfort to see a ghostly outline silhouetted against the turbulent surf and make them think that maybe, just maybe, the souls of our ancestors live on in eternity, yet still have the ability to visit their earthly home on occasion.

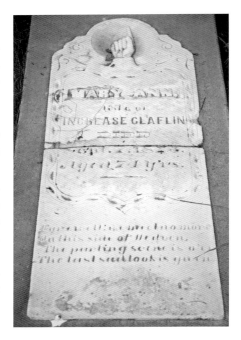

Mary Ann Claflin rests in the Pioneer Cemetery along with other original settlers. The Claflin and Thorp clans founded Fish Creek, and many believe the old ancestors still walk the forests and roads they called home.

PART II

THE DEATH OF INNOCENCE

*I suppose that she wanted to get another proof that the place was haunted,
at my expense. Well, it is—swarming with ghosts and goblins!*

—*Emily Bronte,* Wuthering Heights

THE PRECOCIOUS HUEY MELVIN

The eastern shore of Green Bay, near the current town of Fish Creek, was home to the first permanent white settlers of the northern Door Peninsula. Although hunters and fishermen had traversed the deep wilderness for more than a hundred years, it was not until 1844 that Increase Claflin, a farmer and horse breeder, moved his family from Little Sturgeon Bay to a site that is now part of Peninsula State Park. He was soon joined by neighbor Asa Thorp, a cooper (barrel maker) from Upstate New York. Although Claflin was happy enough to raise his family and tend to his small homestead, Thorp was an entrepreneur and had visions of creating a thriving town. He began by building a sturdy pier to entice the ships that sailed past with cargo bound for the settlement of Green Bay. His skills as a cooper were in high demand; barrels were the only containers used to pack fish and other perishable commodities. Thorp was talented, reasonable and fast, and his reputation drew in fishermen in droves. The small community grew quickly. A sawmill, general stores and hotels sprang up, including Thorp's own inn, the aptly-named Thorp Hotel.

As might be expected in such a small town, many marriages occurred between the Thorp and Claflin clans. In fact, it seems that most of the long-time residents can trace his or her heritage back to one bloodline or the other, sometimes both. They were hardworking and industrious folk, and much of the economic development of the area can be traced back to these founding fathers. As the crumbling gravestones in nearby cemeteries indicate, many

Huey Melvin was born in a cabin on the property of the Thorp House Inn. His mother, Emma, was the daughter of Jacob Thorp.

Thorps and Claflins lived and died in these parts. Unfortunately, some died much too soon.

One of those lost innocents was Huey Melvin, the six-year-old son of Emma Thorp Melvin and John Melvin. Huey was born in December of 1898 and named after his paternal grandfather. His maternal grandparents were Maria Claflin Thorp and Jacob Thorp, brother of Asa. His older relatives had built the town, and Huey blossomed under the loving and watchful eye of the large extended family. By all accounts, he was a gregarious and intelligent child, if somewhat mischievous. The townsfolk laughed at his antics as he played along the shoreline or visited the keeper at nearby Eagle Bluff Lighthouse.

The summer of 1905 was like most others; the town was filled with tourists from Chicago and Milwaukee that had arrived via the Goodrich Steam Line in an effort to escape the stifling summer heat of the cities. Nearly every day, one of the sturdy lake steamers would huff and puff up to the town dock, disgorging the summer visitors. The *Georgia, Alabama* and *Carolina* all made scheduled stops in Fish Creek, and the little towheaded boy often was on hand to greet them. It seemed as though everyone loved

Huey. Like many his age, he looked toward entering school in the fall with a mixture of excitement and trepidation. It would be fun to join the bigger kids in the small school down the road, but it also meant his carefree summer days would be coming to an end. Sadly, Huey never made it to school—that summer would be his last.

Some people say it began with a sliver of wood from a makeshift slide. Others claim the boy stepped on a rusted nail while playing along the lakefront. In any case, Huey fell ill in late July. At first he complained of stiff and painful muscles. Next came the spasms and fever. The local doctor offered up every bit of solace could provide, but the child grew sicker and weaker. On August 8, Huey lapsed into unconsciousness and died, a victim of tetanus. His grieving parents buried their young son in the Pioneer Cemetery near his ancestors, just down the road from the lighthouse he so loved to visit. (The cemetery and lighthouse are now part of Peninsula State Park and accessible to visitors.) His headstone is topped with the figure of a reclining lamb and is engraved with a heart-rending quote: "Our darlig [*sic*] one has gone before, to greet us on the blissful shore." The mischievous Huey, however, seems unwilling to leave for the other shore. Instead, he continues to play and ramble in his familiar territory.

One family that vacationed frequently in Peninsula State Park had

perhaps the most vivid and repetitive visits from Huey. Each year, the parents and their children would spend a week or more camping in the park. At some point, they discovered Huey's grave in the small and hidden ancient cemetery. Touched by the tombstone inscription and the young age of the deceased, they began a habit of visiting the grave often and leaving behind small tokens: a bouquet of wildflowers perhaps, a small toy or a few shiny pennies. The mother especially felt a bond with this dead child, tragically taken from his parents at much the same age as her own young brood. She would talk quietly to the monument, wishing the child peace and blessings.

Huey Melvin's grave still attracts visitors more than a hundred years after his untimely demise.

One year, when the family arrived in Fish Creek for their annual camping trip, they discovered that unusually heavy rains had left the campsites a muddy disaster. Not wanting to spend their vacation wedged in a tiny tent in the middle of what was virtually a swamp, they decided instead to check into a local hotel. In an odd coincidence, they chose a cabin at the Thorp House Inn, a historic bed and breakfast built by Huey's relatives. In fact, Huey had lived and died in a small cabin right next to the property. From all accounts, the family was completely unaware of the connection...until they tucked in for the night.

Hours later, the father was roused by a soft knock at the door and the sound of footsteps. He blinked and looked around, but he couldn't see a thing. Thinking it was one of his own youngsters awakened by some night fright, he asked "What's wrong?" Suddenly, he became aware of a deep chill in the room that sent shivers up his spine. By now, his wife was also awake and sitting up in bed. "What's wrong?" she repeated, still groggy from sleep. Moonlight streamed through the delicate lace curtains, bathing the room in a soft light. And, in the light, they both saw the figure of a young boy dressed in an old-fashioned sleeping gown, standing silently at the foot of their bed. As they watched, the apparition turned and glided noiselessly toward the closed bedroom door and then turned to face them once again. "Come with me" it implored, beckoning with its ghostly hand. It repeated the request, "Come with me!" and then turned and disappeared through the closed door. The couple didn't get much sleep the rest of the night as they huddled close together and tried to rationalize what they had just seen. By morning, as bright sunlight flooded the room, they had managed to convince themselves that it was just some sort of shared waking dream. But unbelievably, that night the ghost appeared again.

This time, the wife was still awake in bed when she sensed a sudden unnatural chill. She immediately elbowed her sleeping husband, and they both lay quietly as the unmistakable sound of a child's footsteps approached. Once again, the small form appeared and beckoned "Come with me" in a plaintive voice before disappearing through a wall. Although they sensed no threat from the apparition—indeed, it seemed friendly—they were still understandably unnerved by the nocturnal visitor. Even so, they felt too embarrassed to mention it to the inn keepers. That morning at breakfast, however, their young daughter cheerfully announced "I saw Huey last night" while munching on her toast. The dumbfounded parents probed for more details, and the little girl patiently explained that Huey had come to her bedroom. They had talked and laughed for a short while before he had

to leave. Suddenly, it all made sense. They hadn't gone to the cemetery to visit Huey yet this trip, so Huey was visiting them. That afternoon, they stopped by the grave with flowers, and the nighttime apparitions stopped. Now, whenever they vacation in Fish Creek, the family makes certain to pay their respects immediately.

They are not the only ones who have encountered Huey. One dark and moonless night, a park ranger was on routine patrol in Peninsula State Park. The park has numerous campgrounds, and the rangers maintain order by wrangling unruly drunks, preventing vandalism and keeping a watchful eye on unattended campfires. This particular night was very quiet, and the flickering of the patrol car's headlights on the low-hanging tree branches was almost hypnotic. It was late, and the officer really didn't expect to see much other than the occasional raccoon or deer frozen in the headlights. Suddenly, he saw movement in his peripheral vision. As he glanced to his right, he spotted a small boy standing in the trees near the side of the road. The child was much too young to be out by himself at this time of night. He appeared to be around five or six years old. The ranger slammed on his brakes and rolled down the passenger window to ask if the boy's parents were nearby. Perhaps they were on a late-night family hike? Before he could

A sign warns visitors not to leave trinkets at Huey Melvin's grave. It is largely ignored.

speak, the child darted in front of the patrol car and ran into a patch of woods to the left, headed toward the nearby Eagle Bluff Lighthouse.

Now he was concerned. There were obviously no adults around, and a young child could be in great danger in the park, especially at night. The lighthouse sat on a tall limestone cliff, and the safety fences and walls couldn't completely contain an unsupervised and curious youngster. A fall would be fatal. The officer gunned the car and pulled quickly into the parking lot in front of the lighthouse. As he did, he saw the child emerge from the woods and run to the keeper's house at the base of the beacon. The ranger turned the wheel, trapping the boy in his headlights and prepared to jump out and give chase if necessary. With his hand on the door handle, he suddenly froze as his senses came into focus. The child had turned to face him, and the officer could see he was dressed in early twentieth-century attire, with woolen tweed knee pants, a ruffled, long-sleeved white shirt and drab knitted knee socks. Perhaps more disturbing was the fact that the officer could see the bricks of the lighthouse *through* the boy's body in the glare of the headlights. Before he could process what he was seeing, the boy turned and simply disappeared into the bricks. The ranger sat there for a long while, struggling to come to grips with what he had seen.

As it turned out, his sighting wasn't the first—or the last—of little Huey in the park. Many others have spotted the mischievous little boy playing near the cemetery or running around the lighthouse grounds. In fact, Huey has developed quite a following. Many of his admirers leave coins and gifts at his gravestone—so many in fact that the park system was compelled to add a vaguely menacing sign, threatening to charge folks with littering under a state statute if caught leaving trinkets. The sign also pleads for cooperation, saying in part "[leaving gifts]...is not the way to honor this child's memory." It doesn't seem to be helping much, however; a recent visit showed a hefty stack of pennies nestled next to the lamb figurine. It seems that Huey is enjoying all the attention as Peninsula State Park's unofficial ambassador.

GRETCHEN OF RANGE LINE ROAD

It seems that nearly every town in America has at least one resident ghost that haunts a particular stretch of roadway. These iconic apparitions are handed down from generation to generation, sometimes tweaked a bit to champion a certain message (don't pick up strangers, don't stay out too late*)*, but the basic legend is often more solid than the specter itself. Washington Island is no exception.

With a landmass of approximately thirty-five square miles, Washington Island is the largest in a string of islands that stretch from Wisconsin's Door Peninsula northward to Michigan's Garden Peninsula. Over centuries, the chain of islands between the two peninsulas went by various names, and ancient maps reflect this confusion: Grand Traverse, Noquet, Potawatomi (multiple spellings), Huron and Louse Islands all have been used, depending upon the cartographer. Today, the grouping that forms the northern boundary of the deadly *Porte des Morts* strait is just known as part of Door County. This cluster includes Washington Island and five surrounding smaller isles—Plum, Detroit, Hog, Pilot and Rock—and combined, they comprise the Town of Washington.

The earliest known inhabitants of the area were the Potawatomi Indians, but they were slowly forced out as white settlers claimed the land. By the late 1800s, Scandinavian immigrants (especially Icelanders), drawn by the area's bountiful waters, comprised most of the population. These sturdy newcomers were often born into the fishing life in their native country and were well suited to island life and climate. As the settlement grew, they

began to clear land for small farms and soon began to produce enough fish, lumber, stone, potatoes and maple syrup to supply to cities such as Green Bay, Milwaukee and Chicago. It was an easy enough task to load the commodities aboard the merchant ships traveling past on the Great Lakes route, and the trade in cash or necessary supplies helped to support the islanders' self-reliant lifestyle. After the Civil War, there was also a small settlement of nine African-American families that were thought to be escaped slaves seeking refuge from retribution. It was—and still is—a beautiful haven for those in search of peace. Tourism bloomed as city folk, tired of the heat, crowding and noise of the city summers fled in droves to the cool and quiet Northwoods to escape.

Today, Washington Island is the only Door County island with a constant year-round population. There are a few more than seven hundred residents, but the summer population can swell to two or three times that number when seasonal visitors arrive. The Scandinavian influence is obvious, from the names in its phonebook to the decorations on houses. One of the most popular landmarks is the breathtaking Stavkirke (Church of Staves), which

The ghost of a legless milkmaid roams the roads of Washington Island.

was built by hand by a group of residents and was based on drawings of one built in Borgund, Norway, in AD 1150. The hand-carved altar panels and whimsical dragon's heads evokes images of brave Norse sailors out to conquer the sea. The island still holds the distinction of being one of the largest and oldest Icelandic settlements outside of Iceland itself. These are strong, no nonsense folks who aren't prone to fits of runaway imagination. That's why the island seems to be an unlikely place for ghosts. At least one ghost, however, continues her eternal restless meanderings despite the disbelievers.

Not far from the Stavkirke, a north–south rural blacktop dissects the island, running from the eastern edge of Detroit Harbor on the south and terminating near

"Gretchen," the ghost of Range Line Road, often disappears into the trees when sighted.

Washington Harbor on the north end. Known as Range Line Road, it cuts a path past farms and fields, forests and shorelines. In the dark of night, the monotony of unbroken asphalt can have a hypnotic effect, rendering sleepy motorists blind to their surroundings—until they see a tall blond girl standing by herself along the side of the road in the pale moonlight. Perhaps they assume it is someone suffering car trouble or a tourist lost on an evening walk. A closer look, however, is bound to send chills up the observers' spines. There is something odd about the girl's appearance; she is dressed like a turn-of-the century milkmaid. In her hands, she holds two pails seemingly heavy with milk. Her expression is blank and detached, her eyes focused on a point far in the distance. Motorists who slow down to offer assistance soon realize that the girl has no legs—her torso appears to be floating above the ground, and a vaporous fog settles underneath her where her legs should be. It is Gretchen, Range Line Road's resident ghost. Before it is possible to regain one's senses, the specter suddenly fades into a mist.

Gretchen doesn't limit her activities to just nighttime manifestations. There have been many daylight sightings as well, usually culminating in her disappearance into a nearby stand of trees. In every case, the shocked spectators mention two distinguishing features: Gretchen is very tall, perhaps close to six feet, and she is either legless, or her legs appear to be vague and indistinct. She is almost always spotted near the side of the road and almost always carrying her pails. No one seems certain who she was or what fate led her to roam Range Line Road in eternity, but there are plenty of folktales.

The most common (and accepted) explanation is that she was a young Scandinavian immigrant brought over to work on one of the island's many small dairy farms in the early 1900s. Some say she was abused and running from virtual slavery; others claim she was a hard-working and deeply valued employee. In any case, one afternoon, as she returned from the barn with her precious harvest of milk, she stepped into the roadway without looking. Depending on the version, she was either struck by a team of horses pulling a heavily laden wagon or by an old automobile. Gretchen was gravely injured, and her legs were damaged or amputated by the accident. After a painful few days, she succumbed to her injuries. Now she walks Range Line Road in a never-ending quest to complete her original journey. Her presence is never threatening but, instead, evokes a feeling of deep sadness, that of an innocent life cut much too short. Perhaps someday her tortured soul will find eternal peace. Until then, she roams the back roads of Washington Island, occasionally startling a motorist on a quiet drive along the lonely blacktop.

A DRIVE ON THIN ICE

The surrounding waters are intrinsically tied to the daily lives of many of Door County's residents. Fishermen, boat builders and the islanders especially look to the deep blue waves of Green Bay and Lake Michigan as a source of sustenance and a routine course of travel. These people often grow up beside the water, sometimes being born into a long heritage of brave mariners. And although they respect the power of the waves, they seem to lose the deep basic fear that might paralyze a prairie-bound landlubber. The water becomes a familiar friend, and they traverse it with ease and grace.

Of course, when the brutal northern winds course down from Canada in the late fall, the sapphire waters gradually freeze and become a frozen white tundra for as far as the eye can see. Life, however, must go on, and the residents cope with the change as best as possible. In the old days, when the ice was solid and thick in the frigid winter, horse-drawn sleds replaced boats (in more recent times, they would be replaced by snowmobiles and automobiles). Crude ice roads stretched from the mainland to occupied islands, marking a passage across the frozen bay.

Nowadays, life is a little different. The Washington Island Ferry operates a daily ferry service aboard the icebreaker *Arni J. Richter.* In 2004, this ship replaced the ferry line's smaller icebreaker, the *C.G Richter*, which had been serving the island since 1950. The *Arni* is almost double the size of its predecessor and much more powerful. It plows relentlessly through the stubborn ice floes, serving as a lifeline to people who would otherwise be cut off from the mainland for months on end. Before the introduction of

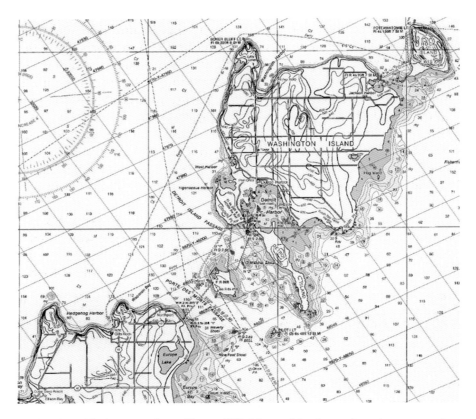

During the cold winter months, residents of Washington Island sometimes drove across the ice to the mainland. Some paid with their lives.

an icebreaker, the route over ice from the peninsula to Washington Island was extremely dangerous and sometimes lethal. Even in the coldest months, the strong currents of Death's Door can create unpredictable and deadly patches of open water. Those who were desperate enough to make the trek usually traveled with great care, because even the slightest lapse of judgment could mean an icy death.

One of the saddest examples of this occurred on a cold, blustery March day in 1935. Basketball was a popular sport on Washington Island, and the local team was playing in a tournament in Ellison Bay. Several carloads of fans and players, as well as the team's coach, drove caravan-style across the ice to the mainland. The safest way to make the trip involved a long westward detour across Green Bay to avoid the capricious currents between the islands, which could weaken the ice and make it unsafe. They

arrived safely and spent the night on the peninsula after defeating their challengers. The celebrants agreed to meet up the next morning for the return trip. When several members of the group didn't show up at the appointed time, Coach Ralph Wade decided to go on ahead without the rest. The others begged him to wait, believing that there was safety in numbers. Wade, however, was in a hurry to get back to Washington Island so that he could open the tavern that he owned. He knew that the regulars would be waiting impatiently at the door for news of the championship game (and perhaps a little afternoon libation). And so, at about 11:30 a.m., Wade and five of his star players piled into his rickety two-door Model A Ford sedan and motored off across the ice.

Unfortunately, in his haste, Wade apparently decided to take a shortcut between the islands, instead of driving the circuitous but safer route to the west of the currents. He must have believed that the ice would certainly be thick enough on that bitter cold morning, and they had the benefit of clear

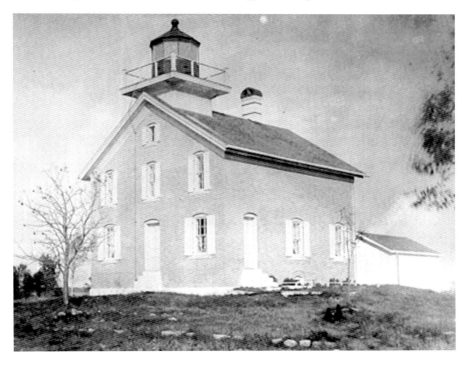

The Pilot Island Lighthouse marks the entrance to Death's Door. Worried townsfolk on Washington Island suspected the dangerous passage had claimed more victims when six members of the community failed to arrive home after a drive across the ice from the mainland. Searchers found a large jagged hole in the ice between Pilot and Plum Islands.

bright daylight to help them steer clear of any questionable patches. But that afternoon, when Wade's bar didn't open at the normal time, regular patrons began to worry. When the rest of the cars arrived safely a few hours later, everyone became filled with a sickening dread. The townsfolk quickly organized a search party and started across the ice on foot. It wasn't long before they came upon an ominous, large jagged hole in the ice near Plum Island. The Coast Guard arrived with ice-breaking equipment and began the long process of dragging the deep waters. After a few days, they made a grim discovery: the Model A Ford with the bodies of Roy Stover, Leroy Einarson and Raymond Richter (of the Ferry Line family) still wedged in the back seat. They continued to search for the others, and they eventually were able to retrieve the bodies of Wade, John Cornell and Norman Nelson from the deep.

The islanders grieved intensely. It wasn't completely uncommon to lose a neighbor to the unforgiving waters, but to lose six at once—especially five young and promising adolescents—was a blow that cut the community to the heart. Instead of celebrating a basketball championship as they had expected, they were attending a rash of funerals. Many swore they would never forget, while others did their best to put the tragedy behind them. It appears, however, that Ralph Wade will never let the memory fade, because some folks swear he can be heard continuing his perilous trek toward the island.

On open water, sound can be very difficult to pinpoint. Sometimes it's difficult to hear a friend who is standing next to you and shouting into your ear when the wind grasps the voice and swirls it away. At other times, a distant voice can echo from a mile or more away with the same clarity as someone speaking across a breakfast table. During the day, the normal sounds of life tend to overtake our senses, and the varied cacophony blends into a steady background hum. It's at night, however, when the daytime noises die down, that individual sounds swirl in invisible eddies around us, catching our senses and stoking our imaginations. When the waters of Death's Door are calm, or covered in a thin veneer of snow and ice, that's when you might hear it.

The sounds begin slowly, barely tugging at the edge of your consciousness. It is distant at first: the unmistakable chugging of pistons in an ancient engine. It might be a car on the nearby blacktop or perhaps a farmer firing up an old tractor. As it draws closer, however, you notice that it seems to be coming from out across the water. It's certainly not a boat in the ice, and it doesn't resonate like a marine motor on open water. As it draws nearer, you

A Model A Ford like the one pictured crashed through the ice on a drive from the mainland to Washington Island. Some people claim it can still be heard chugging along on its journey.

also detect the peal of hearty laughter. It sounds like a carload of youths out for a celebratory drive. Before you can draw any other conclusions, the noise abruptly stops, and you're left with just the soft wind whispering in your ear. You might have just heard an old Model A Ford, chugging along on its way to Washington Island.

CAPONE'S LEGACY

Few histories of early twentieth-century Chicago would be complete without at least a footnote regarding its violent gangland past. Most city leaders, especially during Prohibition, were either controlled or cowed by the mob, a group known simply as the Chicago Outfit. And for many years, the leader of the crime syndicate was Alphonse Gabriel "Al" Capone, better known as "Scarface Al," a name he acquired after a vicious knife fight.

Although Capone was hated and feared by many—including rival gang boss George Clarence "Bugs" Moran—he was also treated as a modern-day Robin Hood by many of the poor immigrants in the city. Capone donated generously to charities and even opened soup kitchens for the underprivileged and unemployed. Of course, all of his money came from illegal operations such as bootlegging, gambling and prostitution. In fact, some estimates place the Outfit's revenue at upward of $100 million per year. What made organized crime in the city so notable, however, was the constant and bloody jockeying for power among various mob factions. Although Capone's Italian gang ruled the south side of Chicago and some suburbs with an iron fist, Bugs Moran's Irish mob largely controlled the north side. Perhaps one of the most widely remembered examples of this gang warfare was the notorious St. Valentine's Day Massacre in 1929. Capone, angry about the murders of some of his associates and also furious at Bugs Moran's brazen hijacking of some of his illegal liquor trucks, set a trap. Some of Capone's men rented an apartment on North Clark Street, directly across from the trucking company that served as the north side

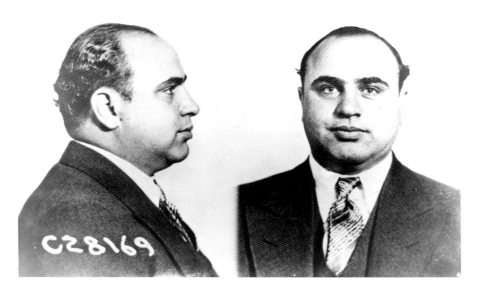

Notorious Chicago gangster Al "Scarface" Capone left a legacy of death in Egg Harbor.

gang's center of operations. The spies watched their rivals' movements, waiting for an opportune time to attack.

On the morning of February 14, Moran and several of his top lieutenants were lured to their headquarters under the guise of an incoming shipment of stolen whiskey. Capone's lookouts, watching from the apartment across the street, reported that Moran was at the office and vulnerable. They were wrong. Albert Weinshank, one of Moran's men, resembled his boss quite closely in looks and stature, even wearing a raincoat and hat that morning nearly identical to those that Bugs himself frequently wore. In reality, Moran was running late and hadn't yet arrived; it was a delay that saved his life.

Witnesses saw a black sedan that appeared to be a police car pull up to the trucking company about 10:30 a.m., and two uniformed officers got out, along with two other men. They walked into the office and declared a raid. Five of Moran's men and two gang associates were inside, and they obligingly lined up against a garage wall, expecting nothing more than a police shakedown or routine arrest—this was just part of their line of work. What the gangsters didn't know was that the "police" were actually out-of-town thugs hired by Capone to disarm the men without raising their suspicions. Their faces were not recognizable to local mobsters, and they were perfectly costumed to look like real cops. With their guard down,

the mob men were sitting ducks when the imposters opened fire with the Thompson submachine guns hidden under their coats. Some estimates say that seventy rounds were fired, a clear case of overkill. The only survivor was a German Shepherd dog named Highball, who belonged to John May, one of the gang associates. It was Highball's terrified howling and barking that later drew attention to the scene and eventually brought the real police, but it was too late. One gangster, Frank Gusenberg, was still clinging to life, but he died a short time later at the hospital. Despite fourteen bullet wounds to his body, he remained true to the mob code, insisting "nobody shot me." Meanwhile, Moran had arrived just in time to see the phony police car and waved his driver on. A few other latecomers in the gang also turned away at the sight of the car. Had Capone's men waited another few minutes to stage their phony raid, the casualties would have been much higher.

When the bloody massacre hit the newspapers, accompanied by gruesome front page photos, public opinion began to turn against the Outfit. Capone was no longer looked at as a kindly benefactor but as a vicious murderer. Ironically, the event signaled the beginning of the end for both gang leaders. Moran held onto his weakened territory until the early 1930s, when the repeal of Prohibition took away bootlegging, his most lucrative business. He eventually left Chicago and moved to Ohio, where he resorted to a life of petty crime. When he died in Leavenworth Federal Penitentiary in 1957, he was a pauper with less than $100 to his name—quite a comedown for a man who was once one of Chicago's richest mob bosses. Capone was convicted of tax evasion and sent to prison in 1931. Although he was released in 1939, his brain by that time was ravaged by late-stage syphilis, and he lived out his final years in Florida with the reduced mental capacity of a child. During his heyday, however, Capone spent a lot of time in various vacation hideaways. Some of his favorite spots were in Wisconsin, including the Door Peninsula. And, in at least one of those places, he has left behind a ghostly legacy that continues to haunt the town of Egg Harbor.

The story begins in one of the oldest buildings in Egg Harbor, a boarding house that originally opened in the late 1800s under the name Kewaunee House. It served mostly lumbermen and sailors, and it included a small saloon. In 1904, John Bertschinger, a Swiss immigrant, purchased it, expanded the building to include a dining room and renamed it the Harbor Inn. By 1912, Bertschinger had had enough of the innkeeper's life and sold it to Murphy Moore, who renamed it Murphy's. Murphy's remained popular for many years and became a frequent hangout for Capone. It was an ideal spot; besides its beautiful lakeside location, the building also boasted a series

of tunnels leading away from its basement and onto the nearby beach. The tunnels (now closed for safety reasons) are likely part of Horseshoe Bay Cave, a natural cavern that is believed to be the second largest in Wisconsin. They were probably first discovered by the Ottawa Indian chief Tecumseh, who used the underground maze to escape attacks by neighboring tribes. They also came in handy for gangsters looking for a quick escape route from nosy Federal Agents. Supposedly, Capone kept a speedboat on the shore. If he wanted to disappear, he could simply bolt down the basement stairs, through a tunnel and onto his boat before the visitors got halfway through the front door.

Although Capone had married his wife Mae at a young age and gave the appearance of a respectable family man, he was actually a serial philanderer with girlfriends and children in various locations. At least one or more of those women lived in the boardinghouse upstairs at Murphy's. According to the locals, an adolescent boy named Jason lived there with his mother and was one of Scarface's numerous unacknowledged offspring. Jason was a smart and observant lad, and he noted several bits of incriminating evidence against dear old dad. He hoped to turn his information over to the authorities, perhaps in an attempt to free his mother from the hold of the vicious gangster. Sadly, Capone found out and, shortly thereafter, Jason mysteriously committed suicide by hanging himself in the attic at Murphy's. Although it was widely agreed among law enforcement that the boy had been "helped" to hang himself, no one was ever charged with the murder.

Jason, unfortunately, was not the only innocent to die at Capone's hand. Another one of the gangster's girlfriends lived at Murphy's (although it's not clear if this liaison occurred before or after the one with Jason's mother). In any case, this woman became pregnant and gave birth to a baby girl. It seems that she tried to blackmail Capone in some manner. Mother and baby disappeared one day and were never seen again. They have, however, been heard with some frequency. Visitors report hearing a baby's cry and a mother's soothing whisper at times when the building is dark and deserted.

The most recent recreation of the site occurred in 1997, when the building became a restaurant, microbrewery and bar named "Shipwrecked." The new owners had no idea that they were purchasing not only a historic property but one filled with supernatural reminders of its sometimes sordid past. In fact, Shipwrecked has had so many ghostly appearances from so many different eras that it must get downright crowded at times. The ghosts include an occasionally belligerent lumberjack from its Kewaunee House days; a woman in Victorian dress who has been patiently waiting

The stagecoach was one of the first means of public transportation on the peninsula. A woman in Victorian dress can sometimes be spotted at Shipwrecked Pub, waiting patiently for a stagecoach that hasn't run in more than one hundred years.

for a stagecoach to arrive since it was the Harbor Inn; and at least four ghosts from Murphy's—Jason, the mother and baby and Murphy's wife, Verna Moore.

In the past, Jason was the most visible, but his hauntings have become less frequent in recent years. Townsfolk used to often report seeing a sad-looking boy peering from the large attic window that faces out toward the street. Sometimes, they spotted the boy perched precariously on the roof. According to local legend, one out-of-towner who wasn't familiar with Jason's tale called the police department one morning in a panic. As he drove into town, he saw the boy on the roof quite clearly in the bright sunlight. Fearing that the youth would either fall or jump to his death, he promptly notified authorities. The police and fire department responded, but the roof was empty. The current owners have painted and decorated the outside in bright colors, and perhaps the new cheery color scheme has helped because Jason sightings are rare these days. But some people still claim to sense his presence in the attic, where doors creak and seemingly pop open on their own.

If Jason fills visitors with a lingering sadness, however, Verna Moore is a warm and protective presence. She flits through the dining room and kitchen,

checking on guests, and she sometimes follows employees to the basement storeroom to ensure that all is in order. In recent years, the owner's son had an encounter that left him a believer. He had gone down to the basement to check on something and heard a distinctly female voice directly behind him. Thinking a customer might have followed him, he turned quickly, but he was all alone. The employees believe that Verna tends to appear when something is going wrong, perhaps attempting to lend a ghostly hand. And so, if you are ever in Egg Harbor and stop by Shipwrecked for a burger and a brew, don't be surprised if you catch a brief glimpse of a grey-haired, motherly woman moving about in the shadows. It's just Verna, making sure all is well.

THE WALKING DEAD

The life of a paramedic is not an easy one. The long hours and hard physical labor can be grueling, and the emotional aspect often heart-wrenching. Most of the folks who choose this profession are tough, resilient and able to remain calm in the most tragic of situations. They are not prone to wild flights of imagination but instead seek the facts in each case. They are trained to make hard choices when survival is something that is counted in seconds, not hours. And that was exactly the kind of choice facing some southern Door County paramedics late one dark and rainy autumn night.

It had been a quiet evening. The cold rain and damp, lingering fog kept many motorists off the road and tucked snugly into their warm houses. Most of the tourists were gone for the season, and the county was settling in for the long cold winter ahead. The emergency responders, with little to keep them occupied, whiled away the hours by performing routine maintenance on equipment and catching up on paperwork. Of course, the quiet never lasts. The call came in at about 11:30 p.m. A vehicle had crashed along a deserted stretch of rural blacktop. According to the dispatcher, it was a bad one. The elderly witness who called 911 to report it said that the car had passed him at a high rate of speed when it suddenly swerved onto the shoulder, lost control and slammed into an ancient oak tree. Smoke and small tongues of fire were escaping from under the wreck, and the passing motorist was too frightened and frail to offer any assistance beyond calling for help. Within moments, the paramedics were en route, with police and fire department vehicles not far behind. Adrenaline ran high as they raced

The Death of Innocence

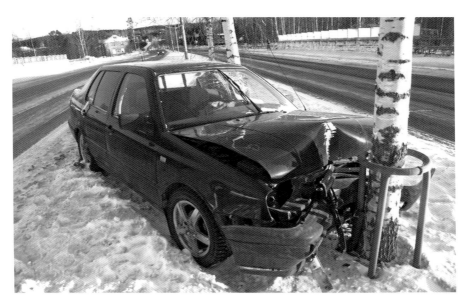

The driver in a single-car collision like this one was seen walking away from his fatal crash.

through the fog, not knowing how many victims they would find or what condition any survivors might be in.

As the ambulance neared the scene, the driver shouted to his partner and pointed at the side of the road. In the swath of their headlights, they could see a young man staggering along the gravel shoulder, obviously gravely injured. His white tuxedo-style shirt was soaked with the bright red blood that was running down his face from a brutal gash across his forehead. His blond curly hair was long—past his shoulders—but it appeared wet and matted from a combination of blood and rain. One of the paramedics was immediately struck by his resemblance to rock guitarist Sammy Hagar. This young man looked a lot like Hagar and was dressed like he might be a musician or local DJ returning from a party. Oddly, he didn't glance up at the approaching ambulance, even though its lights and siren pierced the quiet night like a knife. All of those thoughts were inconsequential, however; this was one of those hard decisions.

Although the natural human urge is to stop and render aid, that wasn't procedure. As the first vehicle to respond, it was their duty to continue to the scene of the accident. They couldn't stop for one victim when there might be five others trapped in a fiery wreck just ahead. The young man's care

would have to fall to the EMTs on the fire truck wailing toward them in the distance. The driver keyed his mic and alerted his colleagues of the "walking wounded" stumbling down the road, and they responded with an assurance that they'd stop and attend. With that, the ambulance arrived at the scene.

It was indeed a bad one. The car must have been speeding like a bat out of hell when it left the road. It appeared to have been airborne when it slammed head on into the unyielding oak. The engine compartment had disintegrated, and the car was broken in two just behind the driver's seat. Chunks of twisted metal lay scattered about, but few were recognizable as auto parts. The shattered safety glass glittered under the ambulance's lights like fallen stars. With a sigh, the paramedic kicked aside a broken beer bottle that told him almost everything he needed to know about the cause of the accident. Luckily, the fitful rain had extinguished any flames, and the wreck was safe to approach. Not surprisingly, the driver had no vital signs and was pinned behind the wheel. They would need the fire department's help to extricate him, but he was well beyond any efforts at resuscitation. As the partners quickly examined the scene, they were relieved to see that there were no other victims beyond the driver and the man they had seen on the road. But somehow, something just wasn't right.

The passenger side door was jammed shut. How had the passenger escaped? It was possible he had crawled through the broken window, but the angle of the wreck made that unlikely. Had he been ejected in the crash? Again possible, but the damage and the field of debris just didn't support it. Also, the windshield on the driver's side showed the classic shattering from an unbelted victim striking it; the section of windshield on the passenger side was still intact. With a growing sense of unease, one of the paramedics walked back around to take a closer look at the deceased driver. As he shined his flashlight on the body, his throat tightened. The man behind the wheel was wet from the rain and bloody, but the matted hair was blond and curly. He wore a white shirt, which was now stained scarlet red. As he tried to collect his swirling thoughts, his partner—the one who had first called out the victim on the road—stood silently next to him and stared into the car.

Before they could speak, a police cruiser and fire engine arrived simultaneously. With a deep breath, the senior paramedic approached the firemen and reported one deceased victim. The fire chief immediately informed them that he and the other firemen had been unable to locate the reported walking wounded and needed more information. Another patrol car was still searching but had found absolutely no sign of anyone along the road.

The Death of Innocence

They never did find a second victim. Both men knew precisely what they had seen, and they had seen it with great clarity. Neither one of them, however, was willing to trust their fragile human senses, preferring instead to chalk it up to a trick of vision. Perhaps it was the fog or an animal... or something they didn't want to consider. That part of the incident was quietly dropped and never appeared in any reports of the night. In a recent conversation with one of the former paramedics, many years after that rainy and strange night, he still insists that it was the dead man he saw, walking down the road away from the crash. Then he laughs and shakes his head ruefully. He doesn't expect the listener to believe his tale. In fact, he can still hardly believe it himself.

PART III

FAVORITE HAUNTS

The popular notion that ghosts are likely to be seen in a graveyard is not borne out by psychical research...A haunting ghost usually haunts a place that a person lived in or frequented while alive...Only a gravedigger's ghost would be likely to haunt a graveyard.

—*John H. Alexander,* Ghosts: Washington Revisited

THE GHOSTS OF COUNTY ROAD T

The life of a farmer is never easy. Being up before dawn to perform back-breaking chores, laboring under the hot sun and struggling to eke out a living against the capricious whims of nature are enough to drain the life out of even the hardiest soul. When you add a houseful of mischievous and raucous spirits into the mix, things become downright intolerable.

And that was exactly the situation facing Elizabeth Jane Ostrand in her modest farmhouse on the outskirts of Egg Harbor. Elizabeth and her late husband, Matthias, had toiled on the small farm for many years, raising their children and living their lives in the welcoming arms of the tight-knit community. There had always seemed to be unexplained occurrences in the old frame house, but supernatural happenings were something that sturdy farm folks tried not to discuss, lest their friends think they had spent a little too much time in the hot sun. Surely, there must be a logical explanation for all the oddities. When Matthias passed away just before Christmas in 1997, however, Elizabeth realized with consternation that she was not alone.

The hauntings began rather subtly, starting with the rickety chicken coop in the backyard. After checking on the hens in the evening, Elizabeth would return to the main house, only to notice that the bare light bulb hanging from the coop's ceiling was still blazing intensely. At first, it was easy to blame the light on a momentary lapse of memory. Elizabeth was quite certain that she had flipped off the switch but shrugged it off to a "senior moment." As days passed, however, the light seemed to take on a life of its own. It was always the same: she would carefully turn off the switch and trudge back to

her kitchen. When she looked out toward the coop, the darned light would be burning like a beacon in the night. Sometimes she would ignore it, and it would later turn itself off just as mysteriously. It must be a short in the switch she figured and so, she had a local handyman stop by to check it out. He found nothing wrong but rewired everything and added a new switch just to be safe. That evening, after bidding good night to her flock, she walked to her kitchen window and glanced out. The light in the coop shone brightly through the dusty windows, casting long shadows across the yard.

A little unnerved, Elizabeth went up to her bedroom and pulled the covers up to her chin. Perhaps after a good night's sleep, she'd feel better. But just as she began to doze, she was stirred by an oddly familiar noise. Matthias had always kept a pair of nail clippers on the bedside table, and he would frequently trim his nails before retiring for the night. It was just one of those silly little things that couples find to argue about when they have been married for a very long time. Elizabeth fretted about nail clippings in the bed. Besides, she hated that annoying sound. She would scold Matthias, and he would dutifully place the clippers back onto the nightstand, only to repeat the scenario a few days later. Now fully awake, she sat up and turned on her bedside light. There, on the opposite table, sat Matthias's clippers. As she watched in shock, the clippers

The lights for this now unused chicken coop once seemed to be controlled by forces beyond the grave.

84

bounced and jiggled across the wooden surface, until they finally dropped to the floor. With that, the noise abruptly stopped.

After a sleepless night, Elizabeth went to visit her daughter and granddaughter who lived nearby. To her surprise, they didn't laugh at her tale or try to convince her that it was just a lonely old widow's active imagination. In fact, the whole family began to share stories of similar experiences while growing up on the property. When Elizabeth returned home that night, it was with a mixture of relief and consternation. She was definitely happy to know that she wasn't losing her mind, but how did one deal with ghosts anyway? She wasn't even sure she *believed* in ghosts, but it did seem certain that something—or someone—was sharing her home. She then marched upstairs to her bedroom, picked up the clippers, tossed them in a drawer and slammed it shut. That night, she didn't even look out the window toward the chicken coop. For the moment, she felt better. But little did she know that the activity was about to increase.

Weeks passed, and Elizabeth immersed herself in family and community. One night, she was roused from a deep sleep by the sound of a voice. Groggy and confused, she thought it might be one of her children dropping by unexpectedly. As she struggled to focus her eyes in the soft moonlight streaming through the sheer bedroom curtains, she saw the figure of a strange woman sitting at the foot of her bed. The apparition sat on the edge of the mattress with her legs crossed, smoking a cigarette and laughing companionably. Elizabeth could see that the woman's hair was tied up in old-fashioned rag curlers, and the smoke she exhaled formed a small hazy cloud that framed her face in the dim light. The apparition was speaking in a low, confiding voice, but Elizabeth couldn't make out the words. Stricken mute with terror, she watched as the ghostly specter laughed once more and slowly faded into a mist. As time went on, the woman with the rag curlers visited a few more times, always laughing and smoking. Elizabeth never could discern who she was or what she wanted, but the figure was friendly and never threatening.

By now, ghostly visitors were becoming a rather common appearance at the old farmhouse. The final phantasm appeared a few years after Matthias's death. Elizabeth came down to start breakfast one morning and found a half-eaten can of beans sitting below the cupboard, the jaggedly cut lid still partly attached. A wave of fear washed over her as she tried to come up with a logical explanation. She called her kids but, of course, none had stopped by to visit during the night and certainly not to raid the cupboard. She tried to push it out of her mind but, a few days later she found some more half-

The old farmhouse near Egg Harbor houses more spirits than humans.

eaten canned goods on the counter. What kind of intruder would break in to eat some cold canned food but leave everything else in the house untouched? Could it be a raccoon? No, raccoons don't typically know how to open a can and certainly wouldn't leave the rest of the kitchen in pristine condition. A few weeks later, it happened again. This time, as Elizabeth stood there in consternation, she heard a laugh. She glanced up at a cubbyhole next to the cabinet and saw a vividly clear image of a man's face. He had dark hair and a thick beard and a distinctive jolly laugh. More annoyed now than frightened, Elizabeth snapped "You're welcome to food, but please don't waste it. And clean up when you're done!" With that, the visage faded away.

On June 1, 2002, Elizabeth passed away in the old farmhouse. The property is deserted now but still belongs to her adult children. Her daughter and granddaughter continue to marvel at the strange occurrences and the generally creepy atmosphere of the farm. The ghosts that roamed the house were always friendly, but their mere presence was of course quite unnerving. Perhaps, they were farmers, like Matthias and Elizabeth Jane, who tilled the rocky soil in an attempt to provide for their families. In any case, the dark and empty chicken coop now stands as a silent witness to the otherworldly presences that sometimes float across the overgrown yard.

THE GHOST BIKE OF RIDGES ROAD

Ridges Road in Baileys Harbor has a long and rich history, although it has gone by many other names throughout its life. It has been designated as a "Rustic Road" by the Wisconsin State Legislature, in recognition of its outstanding natural features, which represent the best of Wisconsin's primal beauty. One only has to drive along its two-and-a-half miles to fully appreciate why the honor was bestowed. As the road curves gently from west to south, the land on the left is covered with towering forests of cedar, pine, maple, birch and hemlock. These trees form a thick green canopy in summer and change to an artist's palette of autumn hues as the days shorten in the fall. To the right, just a stone's throw from the blacktop, is the rugged Lake Michigan coast of Baileys Harbor. Waves crash against the ancient dolomite rocks, fading to a gentle crawl as they lap onto the sandy shoreline that edges The Ridges Sanctuary, the most biologically diverse area in the state. Much of the area is owned and protected by The Ridges or by the adjoining Toft Point State Natural Area. A few homes sit along the shore, but they blend so carefully into the landscape that they are nearly hidden. During spring and summer, when rare and endangered orchids bloom along the roadside, and the trees are filled with the delightful songs of nesting warblers (seventeen different species), it is easy to understand why this is a special place.

The road, however, also has a practical and no-nonsense side. It is the site of the Baileys Harbor Range Lights, which shone across the water from 1870 until 1969, guiding countless mariners into the safety of the harbor.

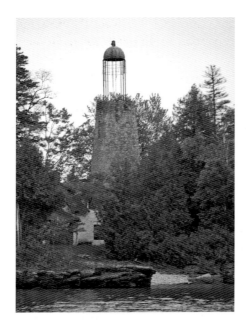

The Baileys Harbor "birdcage" lighthouse still stands as a sentinel at the mouth of the harbor. The light was removed from service in 1869 and has since fallen into serious disrepair.

Although the range lights were replaced by a single automatic navigational light on a nearby bluff in 1970, the old buildings remain as an integral part of Great Lakes maritime history. Unfortunately, that's not the case with another important Ridges Road historical site, the Baileys Harbor Life Saving Station, which sadly disappeared after its abandonment in 1948.

The United States Life Saving Service was started a hundred years earlier, in 1848, when the federal government officially started to sanction and fund shore-based lifesaving stations. Before that, shipwrecked sailors were mostly dependent upon their own survival skills or on a happenstance salvation by a passing ship or brave lighthouse keeper. The first stations were mostly along the eastern seaboard of the United States, but Wisconsin ultimately had twelve, including four in Door County: Baileys Harbor, Plum Island, Washington Island and Sturgeon Bay. The Baileys Harbor station sat on the eastern shore of the harbor, near the point where Ridges Road now intersects Harbor Lane. It was built in 1895 and consisted of a main building with crew's living quarters, a lookout tower, boathouse and various outbuildings for storage and maintenance. Eventually, a long dock and larger boathouse were added to accommodate new equipment.

The crewmen at the station had several tools at their disposal. If weather permitted, they could launch lifeboats into the lake to approach a stricken ship. Early boats were large open surfboats that required a team of six to row. If the surf was too dangerous, however, the rescuers could launch a lifeline to the vessel from the beach, using a large cannon-like device known as a Lyle gun. This lifesaving device was capable of shooting a line to a distance of nearly 700 yards. Because many of the shipwrecks in Door County occurred when passing vessels foundered on shoals near the shore, the Lyle gun was often a safer alternative than sending crewmen out by boat

in the midst of tumultuous waves. Records indicate that from the time the station opened until 1935, the crew responded to 465 calls for assistance, saving untold lives. Finally, in 1915, President Woodrow Wilson signed an act to merge the Life Saving Service with the Revenue Cutter Service and create the United States Coast Guard.

Once the Coast Guard was formed, the personnel at the stations received better pay, retirement benefits and some other perks, but their jobs remained just as deadly. During World War II, several of Baileys Harbor's Coast Guardsmen served on the United States Coast Guard Cutter *Escanaba*, which patrolled the seas of the North Atlantic on search and rescue duty. The ship and her men performed heroically, saving twenty people aboard the *SS Cherokee*, which was sunk by a German U-Boat in June 1942, and rescuing 133 sailors aboard the *Dorchester*, an Army transport ship that was hit by a torpedo in February 1943. *Escanaba* was also credited with sinking at least two German submarines, remarkably within a single day. Sadly, the ship came to a tragic end in June of 1943, during escort duty in the frigid waters between Newfoundland and Greenland. The exact cause of her sinking is still unknown, but it was most likely caused by a drifting mine. Although there were U-Boats in the vicinity, none claimed the kill, and none of the other ships in the flotilla were attacked. Even though the neighboring ships rendered immediate assistance, only two of the *Escanaba*'s 107 officers and crew survived the rapid sinking in the icy subfreezing water.

After the war, life returned to some semblance of normal at the station on Ridges Road, at least for a few years. The commander lived in a small cabin to the east of the main building, and he and his men worked diligently to keep the facility in tip-top shape. He could often be seen riding his old bicycle along Ridges Road, which was appropriately called Station Road at that time. Ultimately, with the advent of safer and more sophisticated patrol boats and equipment, the old Life Saving Stations became obsolete and were closed and abandoned. The Baileys Harbor Station was shuttered in 1948, and the land was eventually sold. The site became part of a neighboring resort, and some of the original Coast Guard housing was turned into vacation cottages and then later torn down to make way for a marina and pricey townhomes. The little cabin that the commander called home, however, still stands to this day. For many years, it was also abandoned, used only for storage by an area developer. And for longer than any of the locals can remember, an old bicycle rested against the weathered gray siding. Spring or summer, fall or winter, the bicycle never moved. At least not during the daylight or while anyone was watching.

The ghostly rider hasn't appeared since the cottage's owner decided to paint and clean the bike. Some people, however, still claim to hear old-time honky-tonk music coming from behind the door of the historic cabin.

Sometimes at night, however, a visitor out for an evening stroll to admire the star-blanketed sky might be in for a frightening surprise. It usually begins with that strange awareness that one is not alone. Oddly, it's often hard to discern the direction of sound along Ridges Road because the churning waves along the shoreline to the west blend with the wind whistling through the thick forests to the east. Add to that the noises from town that sometimes echo eerily across the harbor, and the human ear is hard-pressed to locate a definitive source. But soon the sound becomes recognizable; it is merely a bicycle approaching from somewhere on the darkened road. The tourist steps toward the gravel shoulder to make room for the oncoming cyclist. Slowly, the figure pedals into view. It's clearly not one of those fancy mountain bikes or touring cycles that are all the rage across the peninsula these days. Instead, it appears to be an old and rickety contraption that is in dismal need of some chain grease. The rider, too, seems somehow out of place. As he nears, the visitor squints in the moonlight to see a distinguished-looking older man with a bushy moustache who appears to be costumed in some sort of old

uniform. The pedestrian might offer a friendly greeting but is greeted by silence. As the bike rolls past, it suddenly evaporates into a mist and is gone.

After numerous folks had similar encounters along Ridges Road, they began to make the connection between the ghostly rider and the rusty abandoned bicycle at the old Coast Guard cabin. Eventually, the story reached the ears of the developer who owns the property, and he was greatly amused. He took the bike and cleaned it up and spray painted the entire thing—tires and all—a ghostly bright white. He then placed it back in its original place. Since then, there have been no further sightings of the ghost rider. Perhaps the spirit was offended by the prank, or maybe he simply finds the repainted bike a little gauche. Or maybe he intends to ride once again, some night when the moon is just right and the waves crash loudly against the shore. If and when he decides to head out for a spin, at least his bicycle is all cleaned up and waiting.

THE CURSE OF FIRE

The town of Baileys Harbor gained its name from Captain Justice Bailey, who discovered the peaceful harbor in 1848. Captain Bailey was a Wisconsin-based mariner who sailed a route between Milwaukee and Buffalo, New York, usually hauling grain and other commodities. On a return trip in late fall of 1848, he encountered one of the sudden and violent squalls that make the Great Lakes—especially the rocky Door Peninsula coastline—so deadly for sailors. Bailey had even more reason to worry this time; instead of cargo, he was carrying a load of immigrants eager to take part in the great western land rush. If the ship foundered in these hellish seas, it would be unlikely that even the experienced crew could make it safely to shore, much less the dozens of helpless families crammed into the hull, whose lives depended entirely upon his skill and judgment. He desperately needed a safe place to drop anchor, but refuge was rare on the rugged Lake Michigan coast. With the wind screaming in his ears and his vision nearly obscured by the spray from the waves, he knew he didn't have much time.

Suddenly, off his starboard bow, he saw what appeared to be the entrance to a harbor. It was a risky proposition as the place was uncharted, and there was the very real possibility that the passage was too shallow for Bailey's ship or that it was lined with jagged monoliths of ancient dolomite. With the storm clawing hungrily at the pilothouse, however, it seemed the lesser of two evils. Better to run aground near land than be dashed to bits in the open lake. With just seconds to decide, he spun the wheel hard and headed for the unknown shoreline.

Captain Justice Bailey discovered the sheltering natural harbor that now bears his name during a life-threatening gale. Perhaps his spirit still visits the tranquil haven.

To his relief and delight, his ship sailed without harm past the rocky shoals guarding the entrance and came to rest in a large protected harbor. The crew quickly dropped anchor and hunkered down to ride out the storm. Bailey, however, was quite curious about this hidden sanctuary. Tall stands of forest too thick to allow light lined the shore, valuable timber as far as the eye could see. In some places, exposed shelves of limestone stood at the ready to be quarried and shipped south to the burgeoning cities of Chicago and Milwaukee. Truly, whoever owned this land would become a very wealthy man. When the storm finally subsided, Bailey and a few of his crew members dropped a small boat and rowed to shore. They collected samples of the fine hardwood and stone and gathered large buckets of the wild blueberries and raspberries that sprawled along the shore as a treat for the passengers. But Bailey was saving the wood and stone to show his boss, a wealthy entrepreneur that had come to Milwaukee from the East Coast. Alanson Sweet was a shrewd businessman, and Bailey knew that he would have the money and skills to turn the hidden harbor into a profitable venture.

The captain's instincts were correct, and Sweet did indeed stake a claim on the land and create a booming small town that featured a commercial dock, sawmill, quarry, stores and lodging for workers. He

named it Gibraltar, after the imposing and legendary pillars of stone at the end of the Iberian Peninsula in Europe. Such a fitting and powerful name for the beautiful and rugged settlement! Unfortunately, the name wouldn't stick. To the people who lived there, it was known by the simple and self-explanatory name "Bailey's Harbor." That is the name that stuck, although somewhere in the town's distant history, the possessive apostrophe disappeared permanently. Its modern-day name of "Baileys Harbor" has confounded editors ever since.

The eastern shore of the harbor, which is largely protected by a few tiny islands and shoals, is perhaps the spot where Bailey's crew first landed. The raging waves that pound the outer coastline are mollified here and roll onto shore in a more civilized manner that rarely poses much threat. And this is where Jacob "Jac" Schmitz and his younger brother, George, decided to build a summer resort, next to the old Coast Guard Life Saving Station. Jacob and his wife, Sophie, had owned a beer garden and restaurant in their native town of Milwaukee, but their hearts were in Door County. They held title to an expanse of land to the north of the station and spent as much time as possible at their seasonal home on the property. They loved the area and knew that its natural beauty would have a unique appeal. When Sophie died unexpectedly in 1925, Jac sold everything he owned, and he and his twenty-one-year-old daughter Irene left Milwaukee and moved up to the cabin permanently. George soon joined them, and they began construction on an office, bar, kitchen and dining room. They were able to buy and renovate several small cabins from the Coast Guard, which was reducing its staffing at the station. Although it took many years of sacrifice and hard work, the resort opened for business in the spring of 1935.

They named the resort "Schmitz Gazebos," and it was an instant success. Jac and George were charming and outgoing hosts, and Irene kept the cabins clean and the kitchen running smoothly. Unfortunately, Jac died just five short years later. George and Irene kept the resort going and even expanded a great deal when the Coast Guard Station closed in 1948. By the early '50s, the resort could house forty-five people in studio or one-bedroom cabins, complete with hot and cold running water and Venetian blinds for privacy. They added amenities such as a putting green and shuffleboard court, which helped to earn them the prestigious AAA rating and Duncan Hines awards. In fact, the cocktail lounge was so successful that Station Road became known locally as "Tavern to Town Road."

But running a resort is backbreaking work, and it took its toll. George passed away in 1965, leaving the entire property to his niece. Irene, however,

was sixty-one years old by then and simply didn't have the energy or desire to carry on alone. With a heavy heart, she sold the resort she so loved to Bert Wild, an attorney from Chicago. She would live out the remainder of her life in a tidy white and red house perched near the lake along the southern edge of the property. Bert also loved the area and knew that with a little cash infusion, the humble but successful resort could easily be turned into a trendy destination, drawing wealthy tourists (and their wallets) up from the cities. He didn't waste any time getting started.

One of the first changes Wild made was the name, christening it "Baileys Harbor Yacht Club." The club began with the construction of a huge 12,500 square foot main building right on the lakefront. It was designed to blend seamlessly with the land and made heavy use of local timber and stone. A magnificent slate fireplace served as a focal point near the entrance, and it was flanked by a sunken cocktail lounge featuring a glass-walled patio that overlooked the harbor. The elegant dining room with its haute cuisine quickly gained a reputation as one of the finest in the region. If guests weren't properly impressed with the beautiful view from the patio, they could ascend a sixty-five-foot-high circular iron staircase to an observation room that was modeled after the lookout tower in the old Coast Guard Station. And in order to make travel convenient for his new clientele, Wild added a helicopter pad and an immense pier capable of docking enormous private yachts. McDonald's founder Ray Croc was a frequent guest, either arriving in his luxury yacht *Big Burger*, or dropping in via private helicopter. Bert Wild was thrilled with the resort's success. Irene Schmitz, on the other hand, was decidedly not.

Irene, in fact, was furious about the changes to the property. The huge building restricted her view of the harbor and, when sixty-five- and eighty-five-foot yachts came in to dock, it was impossible for her to see any water at all. And of course there was that damn noisy helicopter! Wild tried to appease her, but there wasn't much that he could do. He certainly wasn't going to raze his luxurious restaurant and lounge just so that a crotchety old woman would have a better view of the lake. At one point, he even offered to have her house picked up and moved to another lot that he owned along the shore, but she would have none of it. Irene swore that he would be sorry someday and frequently told visitors that she wished the whole place would just burn to the ground. She wasn't a cruel woman and certainly wished no individual harm; she just wanted that annoying building gone. Although they remained civil, the animosity swirled like poison just beneath the surface.

Irene Schmitz spent most of her life along the harbor shoreline and was furious when a fancy resort building blocked her view.

Over the years, the property changed hands a few times, with each new owner adding some amenities and tweaking its success. In the late 1970s, SKB Ltd., three Polish men known locally as "The Smolenski Boys," added a sixteen-unit condominium, more cabins and improved the dock facilities, including adding a full-time dock master. In 1982, Maureen Kelley purchased the property and added a small hotel and additional dock space. Her vibrant personality and love of a good party endeared her to the locals, but lengthy sewer construction along Ridges Road made the resort nearly inaccessible for a time. Sadly, Maureen, who had heavily extended herself making improvements, lost her holdings to the bank. Finally, in 1989, the property was purchased by Blue Sky Harbor, a Wisconsin partnership formed by some Iowa businessmen.

Blue Sky Harbor also added improvements and expanded choices. They created two separate dining rooms: The Admiralty Room featured fine cuisine and a formal dining experience while The Bosun's Mate served delicious meals in a more casual setting. Like the previous owners, they worked hard to establish a tentative truce with Irene, who was still occasionally prone to mutter her wish that the place would just burn down. In early 1992, Irene fell ill, and she passed away that April at the age of eighty-eight. She had lived most of her life on that beautiful patch of land and, despite her sporadic

orneriness, the resort owners and employees greatly missed the woman, who had been a fixture on the property for as long as anyone could remember.

Just ten months after Irene's death, on a very cold early February morning, The Baileys Harbor Fire Department received a frantic emergency call; the Baileys Harbor Yacht Club was in flames. The firemen arrived in minutes and quickly extinguished the blaze. Although there was some serious damage, it could be repaired. Most importantly, no one was injured. The main building had not yet opened for the day, and no one was on the premises. The fire had apparently started somehow in the chimney of the massive slate fireplace and had most likely smoldered overnight before finally bursting into flames just before dawn. And although the owners in Iowa had plenty of work ahead of them to restore the property, they were just grateful that no one was hurt.

Later that evening, the neighborhood watering hole was abuzz with talk of the fire. Some of the town's firefighters were relaxing off-duty, and everyone speculated on the cause of the blaze and wondered how long it would take the owners to reopen the popular restaurants. The local news played across the television in the smoke-filled bar as folks nursed their beers and waited for coverage of the early morning excitement. Suddenly, the station interrupted the newscast to broadcast that the popular and renowned Baileys Harbor Yacht Club was engulfed in flames. At first, everyone was confused; did the news people not understand that the fire had occurred nearly sixteen hours earlier? One customer, however, quickly jumped up and ran to the picture window at the front of the bar, which faced across the harbor toward the resort on the far shore. The distant sky was orange with flames that seemed to be licking at the yellow crescent moon hanging low above the horizon. Almost simultaneously, fire equipment from the nearby station squealed past, the tires kicking up dust and gravel as they raced—for the second time in one day—to fight a conflagration at the Yacht Club.

This time, they were too late; the building burned to the ground. The Baileys Harbor Fire Chief and his crew had given all their effort and took great personal risk fighting the blaze, but the strange fire refused to be conquered. Later, fire investigators would determine that sodden cellulose insulation in the walls had hidden some hot spots from the initial fire, allowing the blaze to spontaneously rekindle as it was fanned by the gentle breezes from the lake. It was a total loss. The owners, who were not yet en route from Iowa, were greatly saddened by the news but were once again thankful that no one was injured. After wrestling with their options for several months, they ultimately decided not to rebuild the main structure. They already had plans

When the front desk staff answers the phone late at night at this beautiful resort, they never know who will be calling.

in place to build a series of hotel condos and a swimming pool on the north end of the property, and they decided to proceed along that path. Although Wild's original building had been grandfathered in, recent changes in zoning laws would make it almost prohibitively difficult to create the same type of restaurant and lounge along the protected lakefront.

Today, the Baileys Harbor Yacht Club Resort is as beautiful as ever, with four separate buildings of lovely, fully-equipped rental condos, a stunning stone and cedar lobby, indoor and outdoor pools, a spa, a sauna and various other amenities to please even the most discriminating guests. Sometimes, travelers who once visited the area long ago will ask about the fabled lounge and restaurant, and the front desk staff will graciously direct them to some of the wonderful establishments nearby in town. If they want to know more, there is a framed photo hanging in the lobby that was snapped by one of the townspeople that cold February night. It depicts the old building in the midst of the raging firestorm, with flames shooting from every window and crawling angrily toward the sky. The spot where the building sat is more open now, dotted with just a few luxury townhomes. The marina remains quite active, populated by pleasure boats and fishing charters throughout the summer and fall. And Irene's white and red house still stands on the periphery, looking much like it did while she was still alive.

The harbor is now once again visible from her panoramic front window. As she had promised, the building that blocked her view is gone, burned right down to the ground.

THE ALEXANDER NOBLE HOUSE

Main Street in Fish Creek is a bustling thoroughfare lined with small artsy shops, espresso bars, booksellers and decadent restaurants that serve up home-cooked fare that delights the senses and appeases even the hungriest of diners. During the warmer months, it is a tourist heaven: They come to shop, to gawk, to dine and to take part in all that the quaint lakeshore town can offer. In winter months, the huge throngs are gone, but there are still the snow lovers who come to do all the same things, just at a much slower pace. Like most of northern Door County, Fish Creek has morphed from an agricultural community into one that is dependent upon tourism dollars. One hundred and fifty years ago, its prime exports were fish and lumber; today, it is satiated vacationers.

Fish Creek was first settled in 1844 by Increase Claflin, who moved his family to a tract of land that is now part of Peninsula State Park. He was soon joined by Asa Thorp, a cooper from the east who settled nearby. Claflin was a quiet man who simply wanted to make a living on the rugged homestead by fishing, raising horses and growing a few small crops. Thorp, on the other hand, was a dynamic entrepreneur who dreamed of turning the area into a profitable community. He began by building a sturdy pier to lure the schooners and steamships that ran up and down the Green Bay coastline. Word spread quickly and soon the dock was crowded with fishermen and merchants waiting to snap up barrels Thorp made at a fair price. Not long after, Thorp built The Thorp Hotel.

Soon, other merchants came to stay. By the late 1850s, the community boasted three general stores, some churches, a school, a library and several other businesses. All of this activity attracted the attention of Alexander Noble, a Scottish immigrant who had moved to Chambers Island in 1856. He had built a sawmill on the island and oversaw what was a busy and successful lumber camp. Island life was hard, though, and Noble realized that the up-and-coming town would provide more opportunities for his growing family. And so, in 1862, he packed up his wife and children and moved to the mainland. Noble was an educated and industrious man, with plenty of talents to make a living. He immediately staked a claim on three hundred acres to the east of town, and the grant was signed by President Abraham Lincoln.

Increase Claflin was the first permanent white settler of Door County. This new monument honors him and may help to appease his wandering spirit.

Farming was not an easy proposition in Door County. The topsoil is unusually thin and, though the average depth is about three feet, it is sometimes only a matter of inches between the surface and the dolomite bedrock. To make matters worse, early farmers had to first clear away eons of wave-tossed loose rock—sometimes large boulders—before they could till the sparse soil. To this day, many of the boundary lines in the county are beautiful stone fences. These were not built for their apparent cosmetic appeal but morphed naturally as farmers searched for a spot to pile all the rocks. The soil is rich, however, and the weather moderate, so the small plantings produce abundantly. Noble grew fields of peas, corn and other crops, and he also kept livestock. He also served as the town blacksmith, shoeing horses, repairing wagons and creating hand-forged tools for lumberjacks and fishermen. It's likely that he also provided his neighbor, Asa Thorp, with the iron hoops needed to hold the barrel staves together. Noble and his wife, Emily Vaughn Noble, raised three children on the humble farm.

After Emily's death in 1873, Noble remarried. He and his new wife, Maria Campbell Noble, went on to have four more children. By this time, he was

well established and respected in town, and he decided to build a proper house for his growing brood. He purchased a plot of land from Asa Thorp right in the center of Fish Creek, at the current-day intersection of Main Street and Highway 42. Up until that point, all of the homes in the frontier town were log cabins, but Noble wanted something better. Using his own handmade tools, he set to work on the construction of a grand two-story Greek Revival-style home. The building's interior walls are made of lathe and plaster, unlike any local homes of the era. The large covered porch that sprawls across the front of the home invites visitors to stop and rest a spell, and the surrounding gardens are a peaceful oasis. Noble was active in local politics and served as a town chairman and county board member. Eventually, he was named postmaster, and the town's post office was located in his home's spacious front parlor.

Alexander Noble passed away in 1905, at the age of seventy-six. Marie lived until 1932, and the house eventually passed to Dr. Gertrude Howe, Alexander and Marie's granddaughter. Dr. Howe was an old-time family doctor who ran her practice out of the home. Upon her death in 1995, the property was acquired by the Gibraltar Historical Association (GHA). To their amazement and delight, it appeared that for generations, the Noble

The Alexander Noble House has housed the town of Fish Creek's post office and a doctor's office. It is now a museum.

family had rarely discarded anything. Alexander's old blacksmith tools were still sitting in the garage, as if awaiting an old wagon to roll up in need of repair. Many of his papers were still neatly filed in boxes, including the 1874 deed signed by Asa Thorp. Gertrude's medical supplies and office furnishings remained, as did the skeleton she used to study anatomy. Although the house itself was sorely in need of repair, the rooms were filled with enough artifacts to restore the building as a museum. The GHA registered the property with both the Wisconsin and the National Register of Historic Places in 1996 and, finally, in 1998, the painstakingly restored Noble House was opened to the public with tours and events.

The GHA knew that people would be enthralled by the historical significance of the home and its contents, and it trained its docents carefully. What it didn't expect, however, was that it would receive periodic "assistance" in greeting guests and showing off the premises by none other than Alexander and Maria Noble themselves. At least, that's who seems to be walking the hallways, floating past mirrors and peeking out of windows. And they're not alone. Some claim that the house was haunted by the ghost of Emily, Noble's first wife, shortly after it was built! Legend has it that Emily gave birth to a stillborn child some time before her death. After she died, while Alexander was still grieving, another tragedy struck. Their log farmhouse caught fire and burned to the ground. Although he and the children escaped unharmed, most of their possessions were lost to the flames, including all of their mementos of Emily. When Alexander remarried and moved his children and new wife into the Fish Creek home, the children soon began claiming that they sometimes saw and heard their mother calling to them from the back garden.

The apparition that appeared way back then still manifests today. It always begins in the back garden, in a shady area that seems much cooler than the ambient temperature. A gentle mist rises slowly from the mossy ground, swirling between the trees. Gradually, it seems to take on a vague shape. A visitor might feel a sudden profound sadness, although some people experience a sense of peace and calm. There, standing near the home, is a woman dressed in white, carrying a tiny baby. The figure moves slowly toward the rear door, her arms outstretched as if handing her precious bundle to an unseen companion. In the blink of an eye, she is gone. The mist slowly settles to the ground, leaving the viewer confused and unsettled. Although the Noble children reportedly took great comfort in their mother's occasional visits, some Door County tourists have not had the same reaction.

The ghosts inside the house are quite active as well. In fact, some sources claim that the Gibraltar Historical Association receives more than fifty pictures each year from guests who have returned home, only to find something in a photo that they didn't see at the time they snapped the shutter. In these days of digital photography, the shock is often more immediate: a ghostly image appearing on the camera's LED screen that was undetected by human eyes. Although strange noises, ghostly footsteps and ethereal voices can be heard at various times and in various places in the home, there seem to be two main points of activity. The first involves the old mirrors in the home. It is said that when a visitor stares at his or her own reflection in a mirror, they will often be startled by the image of a woman in Victorian dress floating past. The second hotbed of spectral activity is the upstairs bedroom, which faces Main Street. Townsfolk say that it is not uncommon to glance up at the window and see the shadowy figure of a distinguished looking gentleman or a woman in white lace peering back at them.

The GHA holds frequent events at the house, and these have stirred up some otherworldly excitement as well. Every few years, the staff reenacts

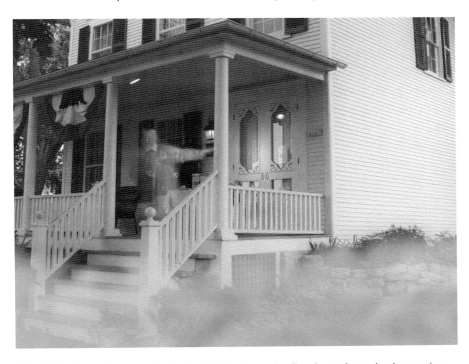

The Noble House is reportedly filled with friendly and polite ghosts that enjoy interacting with guests.

a Victorian Age funeral for Alexander. As was the custom of the era, they cover all the mirrors and windows and stop the clocks. The casket is set out for viewing in the main parlor, while a horse-drawn hearse waits patiently for the funeral procession to begin. In numerous photos taken during these events, there are unexplained orbs of light dancing around the casket. Once, a chair appeared to burst into flames but, upon closer inspection, there was no fire. The ghosts are typically discreet and polite, however, and never act out in a threatening manner. Indeed, they are quite charming hosts.

Alexander, Emily and Maria are buried in a family plot at Ephraim Moravian Cemetery, although it is perhaps inaccurate to call the cemetery their final resting place. It appears that this family has no intention of resting, at least not when tourists are around to enjoy their antics.

TOM NELSON AND HIS BITTERS CLUB

Washington Island is a place founded by brave immigrants, many of whom battled starvation, disease and poverty on their respective trips from the old country. Much of the population even today is Scandinavian, and they are rooted in the land by ancestors who came to this enchanted island to earn a living by fishing its waters and plowing its lands. It was not an easy life back then, but those who thrived were rewarded by living in a close-knit and successful community on an island steeped in natural beauty.

Tom Nelson was no exception. He emigrated from Denmark in the late 1890s and settled near Detroit Harbor. The details of his early years on Washington Island are a bit sketchy. Some say he built his saloon in 1899; other records say it was built in stages beginning in 1902. In fact, the records of the era can't even agree upon his surname, logged as both "Nelsen" and "Nelson." And although almost everyone knew him as Tom Nelson, the sign over his establishment still quite clearly spells out "Nelsen's Hall." It seems that Tom himself was either ambivalent or purely disinterested in such details.

In any case, Nelsen's Hall quickly became an important community center. In its various incarnations, it has served as a tavern, dance hall, movie theater, dentist's office and ice cream parlor. During Prohibition, it was a "pharmacy" dispensing nothing but 90-proof Angostura Bitters. Tom, you see, was the ultimate opportunist. He was hard-drinking and hard-working and wouldn't let something like a trifling constitutional amendment stand in his way. He was quite fond of his bitters and reportedly drank a pint a

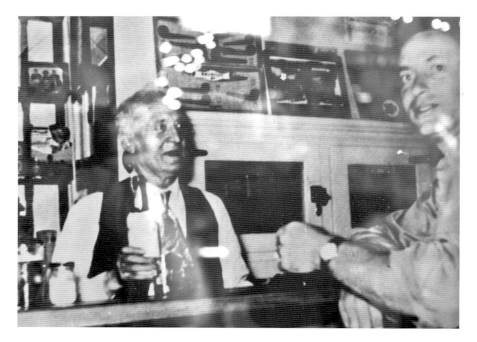

Pharmacist Tom Nelson dispensed 90 proof bitters as a cure for stomach ailments during Prohibition.

day. He was also fond of the ladies and had a reputation for pinching the buttocks of any young lass who wandered within arm's length.

When the Eighteenth Amendment took effect and outlawed alcohol, Tom was quick to pounce on the fine print, which allowed alcohol to be served "for medicinal purposes." He immediately applied for—and received—a pharmacist's license. At Nelsen's Hall, it was business as usual, although the drink menu was rather limited. Federal Revenue Agents were understandably a bit skeptical about this scheme and quickly raided the tavern. All they found, however, were cases upon cases of bitters and Pharmacist Tom. To prove his point, Tom dragged in a local doctor, who solemnly swore that bitters were an important treatment for stomach disorders. And apparently, the residents of Washington Island were unnaturally prone to gastrointestinal distress, because Tom's business was booming. He became known for his philosophy "Gos de dang it. You are a stranger here but once." The Feds were left scratching their heads, and Nelsen's Hall gained the distinction of being the oldest legally and continuously operated saloon in the state of Wisconsin.

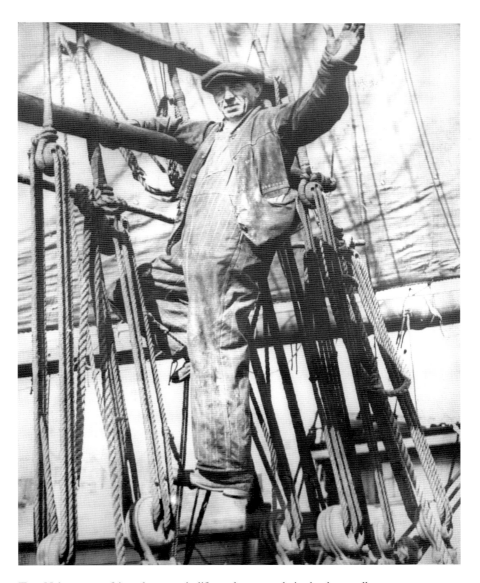

Tom Nelson was a feisty character in life, and apparently in death as well.

Tom lived to the ripe old age of eighty-nine, swilling his bitters until the very end. After his death, the tavern passed on to his nephew Gunner, and Gunner's wife, Bessie. Gunner passed away in 1965, but Bessie continued to run the saloon until 1973, when she sold it to Jim Llewellyn, who renamed

it "Jim's up the Road." In 1991, Jim sold the tavern to the Jiudittas, who ran it until 1999. Finally, Doug Delaporte and Robin Detelo purchased the property and have returned it to its roots. Besides very good food and all the standard drinks you'd expect at a proper bar and grill, the current owners run a very successful "Bitters Club." To attain membership in this exclusive organization, one must simply slug down a shot of Angostura Bitters. This is not as easy as it sounds (it is called bitters for a reason!). After the initiation, the bartender will offer up an official membership card, signed with a fingertip dipped in bitters. One bartender noted that during the busy tourist season, his finger is perpetually stained a deep orange. On average, more than ten thousand people each year take the challenge and join the club. Tom would undoubtedly be quite proud to know that his humble saloon was recognized by the Guinness Book of World Records as the single largest purveyor of Angostura Bitters in the world.

Of course, Tom is probably well aware of the honor, because it appears he is still hanging around. Employees and customers have both reported feeling the touch of a hand when no one was near. On many occasions, the owners have heard footsteps and doors slamming. Once, when Robin was

Nelsen's Hall is the longest legally operating saloon in Wisconsin, due to owner Tom Nelson's unique method for circumventing Prohibition. And yes, the saloon and his name bear different spellings.

bartending, she heard a man's voice ask for a glass of water. She reached for a glass and turned with a smile, but there was no one in the room. Others report sudden temperature drops, objects being moved and unexplained voices. The highest concentration of paranormal activity, however, seems to occur in the hallway leading to the ladies' restroom. Female customers complain of the sensation of being watched, and some have seen ghostly apparitions floating past the doorway. A few have reported being touched but are reluctant to go into detail. It's quite likely that the mischievous Tom is up to his old tricks, patting or pinching an attractive backside as it passes him in the hall.

A GHOSTLY MISCELLANY

Although most of the stories in this book have focused on hauntings of historical significance, Door County has plenty of ghostly visitors that are unknown in origin but who frequently manifest themselves to their occasional human quarry. Maybe they are attached to a particular time and place, or maybe they are just stopping by for a brief scare. We may never know the story behind the manifestation, but that certainly doesn't lessen the disbelief and fear one might experience when suddenly faced with a presence from beyond the grave. But in some cases, humans simply learn to tolerate—perhaps even enjoy—their supernatural guests.

Such is the relationship of Sonny's Pizza employees in Fish Creek and their resident ghost. The restaurant was built in 1965 and once housed a variety of different cuisines before current owner Sonny Thomas opened in 2007. In addition to the dining room and carry-out business, the place boasts a friendly bar that attracts both locals and tourists. One of those locals was an elderly man named Wally. Wally didn't always have a lot to say but would come in on an almost daily basis to shoot the breeze with a bartender and nurse a beer or two. He would usually grab a sandwich or light dinner before leaving, and the employees suspected it was his only daily meal. No one knew too much about him; he didn't seem to have any family or friends living in the area. Over time, he became a fixture at the pizza parlor, sitting quietly on his usual stool at the end of the bar, sipping his Lienenkugel and listening to the friendly banter. One day, Wally collapsed off his stool. The bartender immediately called 911, but it was too late. He didn't survive the

massive heart attack. The bar after that day seemed a bit empty, and the staff realized how much they missed the familiar figure. But as it turned out, his sudden departure was only temporary.

A few weeks later, Sonny was down in the basement storage area taking a quick inventory. He heard a low voice—one that seemed vaguely familiar—and turned, thinking it was one of his employees. But he was all alone in the room. He shrugged and turned back to the task. Suddenly, a cold, clammy mist seemed to form, and the temperature dropped precipitously. Before Sonny could react to this strange occurrence, he felt the grip of a bony hand on his shoulder. Startled, he spun around, but no one was there. He was becoming seriously rattled. Was it a prank by his staff? If so, he wasn't laughing. "All right, who's down here?" he commanded, but there was no answer. And then, to his amazement, things began to fly off the shelf in front of him—nothing breakable, nothing dangerous, but just a few boxed items that slid quietly off the shelf, hovered in the air and then fell softly to the ground. Sonny decided to continue taking inventory later and headed upstairs for a break. All of the employees were busy at various tasks. No one was anywhere near the basement.

Door County trolleys run exciting and fun ghost tours, including a haunted pub crawl, from several locations on the peninsula.

Sonny decided not to mention the peculiar happenings. Perhaps he had just been working too hard and needed to get a little more sleep. Before long, however, he began to hear rumblings from his workers. It seemed that they all had an odd tale to tell. The wait staff spoke of lights flickering for no reason in the dining room. The bartender saw glasses slide across the bar. The cook kept hearing someone speaking to him while he was alone in the kitchen. After comparing notes, they decided that Wally had returned to the place that most closely resembled a home. Now when lights flicker or items move of their own volition, Sonny will simply say "Knock it off, Wally!" and things return to normal—at least as normal as possible for a place that has a customer who refuses to leave, even after death.

Just a short distance down the road from Sonny's is a cluster of cabins nestled in a peaceful grove of pine and birch. They are popular with tourists who want a relatively inexpensive place to kick back and relax and who don't necessarily need pricey amenities such as swimming pools and hot tubs. One small group of Chicago women has been coming to this place almost every year for a "girls' weekend." They shop, go sightseeing, dine and laugh a lot, freed from the stress of husbands or boyfriends, children and demanding jobs. Their last visit, however, wasn't completely stress-free.

After a busy day on the peninsula, they came back to the little cabin long after dark. While some of the girls chatted, one of them, Barb, pulled out the sleeper sofa and crawled under the covers. Just as she began to doze, the mattress collapsed, and she was tossed forcefully onto to the floor. After quickly making sure that she wasn't hurt, the others began to tease her mercilessly about excess wine consumption and natural clumsiness. She laughed good-naturedly along with them as they fixed the bed, but she was secretly troubled. Something was odd about the mishap, even creepy. Right before the mattress collapsed, she had the unmistakable sensation of strong hands shoving her violently off the bed. She struggled to shrug off the feeling, but she didn't sleep well that night.

And neither did Gretchen. As the others drifted to the kitchen to continue their chat, Gretchen decided to call it a night as well. She pulled a blanket and pillow onto the other sofa in the living room, said goodnight to Barb and settled in. Suddenly, she felt someone touch her leg, just above the ankle. She sat up, thinking that one of the other girls must have come back into the room and brushed against her, but there was no one there, just the moonlight trickling through the window and the sound of laughter and conversation floating from the kitchen. Uneasy, she settled down once more, now wide-

awake. And then it happened again. This time there was no doubting that an icy cold hand had rested briefly on her ankle before disappearing. She jumped up and switched on the light, but no one was in the area except her and Barb, who was burrowed under the covers on the other side of the room. Gretchen nervously turned off the light and wrapped herself in the blanket, willing sleep to come quickly. It was going to be a long night.

The next morning dawned bright and sunny, one of those perfect blue-sky days on the peninsula. As everyone awoke, they immediately gravitated to the kitchen, where the enticing smell of coffee greeted them. Pam had awakened before the rest and set the pot on to brew. Gretchen and Barb had each decided privately to remain quiet about their strange encounters. They reasoned that it must have been a flight of imagination, brought on by too little sleep or too much excitement. It sounded crazy, and the others might think they were being silly. They quickly changed their minds, however, when Pam mentioned that she had trouble sleeping because it felt as though someone kept touching her during the night. "Every time I started to fall asleep, it felt like someone tapping me on the shoulder or touching my leg," she complained. The only one who hadn't experienced anything was Kim, who admitted to falling quickly to sleep out of sheer exhaustion.

Who was the mysterious visitor? It's impossible to know if the spirit was somehow connected to the cabin or just a free-floating ghoul that followed them home that night. The women are adamant that they will not let the ghostly night deter them from future girls' weekends in Door County. Next time, however, they might seek out accommodations that are, shall we say, less crowded.

The Baileys Harbor Yacht Club Resort sits on a peaceful stretch of Ridges Road, wedged between Lake Michigan to the west and Ridges Sanctuary and Tofts Point State Natural Area to the east. The location is stunning in its natural beauty, and guests frequently refer to the resort as the best-kept secret on the peninsula. It is truly a special place for those who want to enjoy nature and still have all the upscale amenities of a world-class hotel.

As mentioned earlier in this book, the original resort's restaurant and lounge burned in a mysterious fire during the 1990s. The current resort consists of a striking cedar and stone lobby surrounded by individually owned rental condos. The front desk staff is known for their friendly and helpful manner, and they pride themselves on "going the extra mile" to please guests. During the summer and fall, the place is jammed with tourists, and an astounding 70 percent of the guests are return customers. During the winter, things are

much quieter. Snow-loving vacationers still come up to cross-country ski in the state parks, snowshoe through the forests or relax in the hot tub with a glass of wine, but the off-season months tend to be a busier time for owner visits. Those who own condos at the Yacht Club usually try to leave their units available for rental during the tourist season and plan their own stays for quieter times. The resort is staffed year-round, and both owners and employees take advantage of the slow season to perform maintenance tasks and do any necessary remodeling or redecorating.

Late one very cold and dark winter night, Matt, the resort's assistant manager, was quietly finishing up some paperwork. The place was nearly empty; only two condos were occupied, both by owners. Due to insurance and fire regulations, owners must check in at the front desk just like guests, so that in an emergency, the first responders will know exactly how many people are on the premises and where to find them. The deep silence was suddenly shattered by the front desk phone. Matt jumped, startled by the sound. He reached quickly to pick it up but, when he put the receiver to his ear, he was greeted with a low guttural moan. Immediately, his training kicked in, and he prepared himself for a possible emergency. He looked down at the phone's display, which showed from what room the call originated. But something was wrong. He knew for certain the unit that showed up was empty. "Hello? Hello...is someone there?" he asked, but the only answer he received was that sound. It was almost like a growl.

Now he was concerned. Perhaps an owner violated the policy and didn't check in but was now sick or injured. He quickly grabbed his master keys and rushed to the unit in question. When he arrived, the condo was dark and quiet, and there was no sign that anyone had been there. Confused, he headed back to the front desk. A short while later, the phone rang again. This time he looked at the room indicator before he answered and, to his consternation, it showed a different—but also unoccupied—unit. Once again, there was no answer to his greeting, although he thought he heard the sound of breathing. Someone had to be playing a prank, but how? No one had access to these rooms besides the front desk and the resort manager, who was asleep at home a mile away. Matt pulled on his coat, grabbed a flashlight and headed outside to look at the phone junction box. Everything looked fine. Despite the brutal cold, he took a slow and careful walk around the property. He checked out both of the condos in question from the outside and the inside, tugging on screens, testing doors and wracking his brain for an explanation. Finally, shivering and numb, he returned to his post at the front desk.

Favorite Haunts

The next day, he told Kevin, the resort manager, what had happened. Kevin called the phone company and asked to have the lines checked out, just in case there was a technical explanation. After a thorough testing, the technician reported that everything was in perfect order. That night, the calls began again. Matt wanted to ignore them but couldn't take a chance on the possibility that someone on the property needed help. He searched the rooms each time but found nothing. He was worried that Kevin and the other staff members would think he was making up a story. Why did it only happen when he was there alone? For a few days, things were quiet. Then the calls came again. This time, however, Matt was off and another employee was on duty. At least he had proof that he wasn't crazy!

Once again, the phone company examined the equipment and found nothing wrong. The calls were more frequent now. It was always the same scenario: the front desk line would ring late at night, and the display would show an unoccupied unit. When the employee on duty answered, he or she would be greeted by the sound of labored breathing, a low growl or a muffled laugh. Oddly, it only happened at night, never during the day. After a few weeks, a new twist occurred: some visiting owners began to receive phone calls *from* the front desk or other condos late at night. Of course, no one was ever on the line. Kevin called the phone company for a third time and raised a ruckus. Although they still insisted that nothing was wrong, they grudgingly came out and changed out some equipment. It seemed to fix the problem, and everyone breathed a sigh of relief that there had been a logical, rational explanation behind the spectral communications. Until, of course, it happened again.

These days, the phones are *mostly* normal. But it seems that each time the staff begins to relax and believe the calls have ended for good, the ghostly ringing reappears once more. Matt has learned to take it all in stride. He answers the calls with his usual blend of professionalism and friendliness. After all, a guest is a guest, even if this one "checks in" in a rather non-traditional manner. And return guests are certainly the norm at this beautiful Door County resort.

PART IV

Assorted Oddities, Unexplained Lights and Things That Go Bump in the Night

When I'm asked "Are you afraid of the dark?" my answer is "No, I'm afraid of what is in the dark."

—Barry Fitzgerald

GHOST ANIMALS

When you ask most people what comes to mind when they hear the word "ghost," you'll usually get a rather standard description of eerie wraiths materializing from the mist. Some folks will think of a friendlier cartoon spirit, like Casper or those of *Ghostbusters* fame. Very few, however, stop to consider the phenomena of ghost animals. Ghost animals do seem to exist but make their presence known in much the same way as their deceased human counterparts. Ancient tribes considered these apparitions to be harbingers from the underworld, coming to steal a soul or warn of impending tragedy. Although we'll never know their true intent, many of these spectral creatures seem to show up either to help humans or perhaps just to visit their earthly home.

Author Geri Rider tells a tale of kindness repaid in the form of a ghostly wild bird. According to Rider, one Washington Island resident spent a lot of time and effort feeding the songbirds that clustered around his humble home. One freezing winter day, this man and his friend attempted a late afternoon drive across the ice from the mainland back to the island. Their car became stuck in the snow and ice halfway across, and they had no choice except to begin the long and treacherous walk home. A blinding snowstorm struck, reducing the men's visibility to a few feet. Being lost on the ice meant a slow death from hypothermia, or worse: A misstep off the marked safe path could result in a fatal plunge into open water. Suddenly, a summer songbird appeared in the midst of the wintry blizzard. The bird chirped, flew a few feet and landed. When the men neared the bird, it would repeat

Door County has a rich and vibrant history, but it seems that no one knows the story behind some of the ghostly visitors.

the process. The men followed the creature and its cheerful song until they reached land. Once they reached safety, the bird vanished into thin air.

Another Door County native tells of being saved from his burning home by a pet dog long since dead. He and his wife were asleep upstairs, and their two small children in a downstairs bedroom, when an electrical malfunction started a blazing fire in the family room. The man was awakened by the barking and whining of Buster, the family's black Labrador retriever. The thing was, Buster had died nearly nine months earlier. The family made it to safety, thanks to the pooch that remained loyal, even in death.

Sometimes the apparition has no ready explanation. Leslie, a Door County farmworker, had a ghostly encounter at a dairy farm. Here, Leslie describes what happened:

One day when I was making the rounds feeding the calves, about five months ago, I was giving one of the older pens of calves their grain. I noticed one of the calves was standing back from everyone else, not rushing to eat. I still remember her number. 1781. After I fed the pen their food, I stood and watched 1781, as it was my job to report sick calves to my boss, and also, [I knew] that this one had suffered from pneumonia on several

occasions. 1781 did not really move for the whole minute that I watched her. All she did was stare at me and shuffle her feet a bit. Getting bored, I got in the truck and drove away to find my boss. When I found him, I told him and he wrote the calf number down and said he would check on her later. I thought nothing more on it and left for the day.

When I went into work the next morning I looked everywhere for 1781 but I couldn't find her. I asked my boss if she had to be put down and he said she wasn't there. I questioned him further and asked what he meant. He then said he checked his computer and that 1781 'didn't exist anymore'. I gave him a sideways look and asked when she died. Apparently, she died two weeks before.

Although we will never know what the ghost calf was seeking, or what its message might have been, it was an encounter that Leslie will likely never forget.

STRANGE CREATURES

It's scary enough to have a ghostly meeting with a beloved pet or even just a familiar animal. Some Door County residents, however, have encountered creatures that are not found in any typical pet shop or zoo. These beings of the night are eagerly sought and hunted by cryptozoologists (people who search for animals whose existence have not been proven). Probably the most well-known cryptid is the infamous Loch Ness monster. "Nessie," as the beast is known as, has provoked controversy over its existence since as early as the sixth century.

Although no sea monsters are known to exist in Door County, there have been plenty of reports of other unlikely beasts. One sighting of a large, furry apelike creature that fits the description of the fabled "Bigfoot" (also known as Sasquatch or the Yeti), happened in southern Door County. A woman who went by the initials B.J. was charged by the creature one early spring afternoon when she disturbed it in a thicket behind her home in Forestville. She got a very clear look at its back in the bright daylight, which she described as being covered in thick reddish-brown fur. Suddenly, it turned and crashed through the trees toward her. She flew back toward the safety of her home. B.J. claims she did not see its face, although she did hear deep grunting and snorting unlike any other animal she had ever heard. It apparently stopped its charge at the edge of the trees and never stepped into the open. She was terribly shaken by the encounter but couldn't figure out what she had seen. Its size and power seemed to suggest a bear, but it certainly didn't look or sound like any bear she had ever seen. B.J. contacted the Wisconsin

Assorted Oddities, Unexplained Lights and
Things That Go Bump in the Night

Department of Natural Resources (DNR) for information. They told her flatly that the only bears in Wisconsin are the common black bears, which never go through a reddish-brown phase. She still can't explain what she saw that day, but she's certain it wasn't any animal known to roam these woods. And, although hers isn't the only claimed sighting of a Bigfoot-like creature, it was the closest and clearest encounter recorded in the area.

There have been other reports of a strange half-man, half-beast that seems to roam the back roads near the Sturgeon Bay Ship Canal. One young family had an experience many years ago that continues to haunt them. Late one summer night, they were driving from Chicago to a hotel in Gill's Rock. After stopping for a snack in Sturgeon Bay, the husband took a wrong turn and wound up on a narrow, deserted road near the canal. It was a dark moonless night, and only the arc of the headlights illuminated the surrounding brush. Suddenly, the man spotted something large moving near the shoulder and slammed on the brakes, expecting a deer to bolt in front of the car. What stepped into the road, however, was no deer. It looked like a very large, somewhat shaggy grey wolf. At that time, there were no wolves on the peninsula, but that wasn't the most disconcerting issue—this creature was walking upright on two legs! It turned in the glare of the headlights and snarled toward the car.

The woman let out a scream, which roused the two preteen children sleeping in the back seat. As all four watched, it stared at them for a long moment, snarled again with a deep rumbling growl and then turned and walked back into the trees. Its gait was steady, as if bipedal movement was its norm, although its upper back appeared hunched. Both parents and children had seen plenty of bears in their travels through the Northwoods, and all agreed it was *not* a bear. It was far less bulky, and its fur was longer and gray in color. The face seemed oddly human-like, although it too was covered in fur. As they sat there, momentarily stunned, an angry wailing roar came from the brush. The husband immediately gunned the car and sped away. The family breathlessly discussed the sighting all the way to the hotel and finally decided not to tell anyone. The father was afraid that the locals would laugh and assume that the "city folks" had been startled by a large raccoon or something much less sinister than what they'd actually seen. It looked like a werewolf, but werewolves don't really exist. Or do they?

UFOS AND ALIEN VISITORS

U nidentified Flying Object (UFO) sightings are common in Door
County. What is perhaps surprising is the remarkable consistency
of the reports. In the vast majority of cases, a series of strange lights are
spotted to the north over Lake Michigan. A smattering of sightings have
been reported over Green Bay, but the mysterious lights always seem to be
out over the water and typically at a rather high altitude.

It would be really easy to brush these off as airplanes, satellites or planets
visible in the endless clear skies of northern Door, but the rest of the facts
don't fit. Many of the witnesses have been pilots, engineers and others
who aren't easily fooled by a passing jetliner or shooting star. Each of the
accounts describes wildly varying speeds and trajectories or patterns that are
unlikely to be flown by traditional aircraft. For example, one sighting that
occurred in 1999 in Sister Bay was witnessed by at least eight people, who
watched for nearly two hours as a bright white light zigzagged, dropped,
shot straight up and changed direction at high speed in the night sky. At one
point, they saw a strong beam of light emit from the object, which suddenly
reversed direction and flew away at a high rate of speed before returning
to the area and flying in spirals. They discussed the possibility of military
aircraft, but the directional changes and apparent speed just didn't add up.
One witness noted that the object did not appear to lose speed as it turned
but seemed instead to simply reverse direction. Perhaps these strange lights
were military flares blowing in the wind? Another witness conceded that was
possible, provided that the winds aloft were in the supersonic range. During

the spectacle, a high-flying commercial jet passed far overhead, which gave them a frame of reference. It didn't, however, make them feel any better. The mysterious light simply defied explanation.

In other sightings, witnesses often describe a series of lights that typically vary in pattern and speed. One report from Washington Island mentioned a long cylindrical object out over the water with four very large bright lights that flashed in some sort of pattern. One of the two witnesses was a pilot, and he guessed the object was a few miles out and about three thousand feet above the water. Of course, it is nearly impossible to accurately gauge distance and altitude over water, especially at night, but this was a trained observer who was quite used to seeing other aircraft. This object was like nothing he had ever seen before. While they watched, it suddenly flew straight up at a high rate of speed and disappeared. Oddly, it made no sound, even though the night was quiet and clear. They reported their observations to the Coast Guard.

Another strange sighting happened on a dark rural road in 2002. Two men were walking home from a relative's house on a moonless night. Suddenly, they were nearly blinded by two brief but intense bolts of white light. When they looked up, they saw a rectangular object floating above them in the sky.

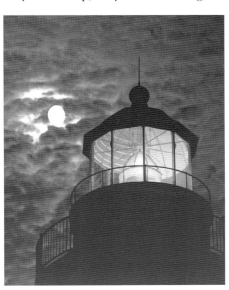

As they watched, jagged streaks of light appeared to ricochet around inside the object, like lightning trapped in a box. And although it seemed to be relatively close to them, it was absolutely silent. Just as suddenly as it appeared, it went dark and disappeared. There were no power lines or transformers along the path the men had taken, nor were there any weather issues to suggest ball lightning. Besides, as one of the men wryly pointed out, ball lightning typically doesn't display in a perfect rectangle. The two were quite shaken by the encounter and still have no explanation for what they saw.

Ghosts aren't the only strange visitors in Door County. The nighttime skies sometimes harbor UFOs.

Humans, however, apparently aren't the only species to be rattled

by such strange encounters. One cold December morning in 2004, a goat farmer went out to milk his goats before sunup. As he approached the barn, he spotted a strange white light in the sky a short distance to the east. It seemed to be hovering, but there was no sound. It was much too low and too close to be a commercial aircraft, and it also didn't have the red tail beacon or any of the other identifying lights of a commercial craft. For a brief moment, he wondered if what he was seeing could be a planet hanging low in the predawn sky, but it did show some minor jerky movements. Suddenly, the object shot straight up into the sky at a phenomenal speed before it disappeared from view. Almost immediately, his goats began to shuffle and bawl fearfully. He went into the barn and did his best to soothe them, but they gave very little milk that morning.

Although UFO sightings in Door County occur pretty consistently each year, there are certain times of the year when the sightings peak. Such was the case in spring of 1952, when a rash of sightings had the whole county on edge. In fact, the news reported so much on the phenomena that it inspired a musical comedy written for the American Folklore Theatre, entitled *Packer Fans From Outer Space*. The play was described as:

> Based (very) loosely on actual events, PFOS follows the exploits of Juddville fruit farmer Harvey Keister. Harvey, a big fan of the Green Bay Packers, is called upon by a group of Packer aliens to save their planet from the evil Space Bears. Marge, his Chicago Bears-loving wife, fears for his sanity. The actual events that were the inspiration for this offbeat musical are several UFO sightings over the skies of Door County in the Spring of 1952, and the 1953 tie game between the Packers and the Bears.

Of course, truth is sometimes stranger than fiction. Just two decades later, Dean Anderson, a greenskeeper at Peninsula State Park, spoke of an ongoing series of communications with aliens that visited him in the predawn hours at the golf course, from 1973 until about 1979. According to Anderson, a flying saucer he saw in 1975 had a "bright, gray shiny metallic finish, a beautiful gold glistening band around the center, and flashed red and green lights. I knew it had to be a laboratory." By 1976, he was frequently in contact with the humanoid creatures and they even went so far as to bring him a gift of a gold-colored amulet.

Anderson seemed rather matter-of-fact about his newfound friends and explained that they were just stopping by to sample and test some of our local flora and fauna. In late 1976, a male and female alien reportedly stopped

to shake hands and introduce themselves to Anderson: "I am Sunar, I come from Jupiter. This is Treena. She comes from Saturn." They also explained that one of the previous visitors he had encountered was Muton, who was from Mars. It's not clear what interplanetary space terminal they were using to hook up together, but Anderson was apparently satisfied by the explanation. Amazingly, they spoke perfect English and seemed to have no difficulty maneuvering about in our atmosphere. On at least one occasion, the greenskeeper decided to take an intragalactic joy ride with the visitors. He left his boss, park superintendent Ralf Halvorsen, a note saying that he was being picked up by a spacecraft and was not sure when he would be back. Halvorsen took

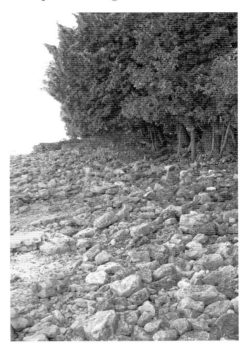

Door County's rocky and deserted coastline is a great place for watching the sky, but sometimes people see more than they bargained for.

it in stride and asked his employee to please let him know when the blast off was scheduled.

By 2004, Anderson had retired and was reportedly in poor health. A team of local reporters who were writing a story on Door County UFOs attempted to interview him but were rebuffed by his wife. Barbara Anderson explained that Dean couldn't safely speak to them because "he's under surveillance by the FBI," and his "guardian angel" would have to give approval for the interview and is "very touchy." They never did get the interview, presumably because the guardian angel had scheduling difficulties. Somehow, the premise for the *Packer Fans from Outer Space* doesn't seem nearly as far-fetched anymore.

ABOUT THE AUTHOR

G ayle Soucek is an author and freelance editor, with several books and numerous magazine articles to her credit, including *Door County Tales: Shipwrecks, Cherries and Goats on the Roof* and *Chicago Calamities: Disaster in the Windy City*, both books published by The History Press. She once served as managing editor for the Chicago art and entertainment biweekly, *Nightmoves*.

She and her photographer husband divide their time between their home in Chicago and their second home in Baileys Harbor. In her years in Door County, Gayle has seen and heard some pretty strange stuff. Amazingly, not all of it involves the Packers, the Bears and Leinenkugels.